IMAGES
of America

DeKalb

IMAGES
of America

DeKalb

Jo Fredell Higgins

ARCADIA
PUBLISHING

Published by Arcadia Publishing
Charleston, South Carolina

Printed in the United States of America

Library of Congress Catalog Card Number: 2004105902

For all general information contact Arcadia Publishing at:
Telephone 843-853-2070
Fax 843-853-0044
E-mail sales@arcadiapublishing.com
For customer service and orders:
Toll-Free 1-888-313-2665

Visit us on the Internet at www.arcadiapublishing.com

*To my sister Pat Fredell Hagemann and to my brother Ray Fredell II.
With loving wishes.*

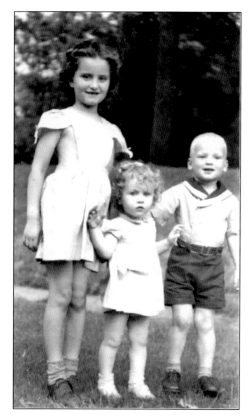

On a summer's day, 1947, sister Patty, the author, and brother Ray are captured on film by their beloved Uncle Emmett Scherer at Glen Oak Park in Peoria, Illinois.

CONTENTS

ACKNOWLEDGMENTS

"Blue shadows spot the road. The clock is faceless, the bell tower silent with blue wind winding through the shutters."
–Peter Balakian, "L'Eglise d' Auvers: The Blue Church"

Seductively, the summer palette of colors attracted me. The sunlight sparkled and the sky was a brilliant blue over the cornfields of DeKalb, Illinois. It was summertime, 2003. To write such a photo history as this, I needed to meet the residents of DeKalb and record their histories. My journey had begun with research at the many historical museums and libraries in order to decide what was important to comment upon and to identify the prominent builders of DeKalb. There were many distinguished persons who helped make this book a reality and to those I extend my grateful thanks. I acquired several researchers who found very specific information for me and with whom I shared many a delightful lunch at the Hillside Restaurant in DeKalb. They are Mayor Greg Sparrow, Waubonsee Community College president Dr. Christine J. Sobek, Suzanne Higgins, Sean Higgins, Mark Starkovich, Alice Erickson, Steve Bigolin, Helene Reed Tyler, Bud Tyler, Barbara Wallin, Jim and Catherine Hovis, Joan Hardekopf, Jessie Glidden, Charles Bradt, Ethel Taylor, Ken Cammeron, Darla Cardine, Bruno Bartoszek, Biruta Strike, Dan Grych, Kathy and Chris Hubbard, Kim Kubiak, Yvonne Johnson, Marilyn McKay, Librarians Elasa Papadimitriou, Dee Coover, Paula Torgeson and Teresa Iversen of the DeKalb Public library, Candy VanTine of the Eola Branch Library in Aurora, Marge Dumsdorf, Sally Stevens, Don Mack, Gerald Brauer and the Ellwood House Museum, Estele Von Zellen, Sally Fauw, Glen Gildemeister, Michael Malone and Lee Ann Henry of *Northern Now*, Wynne Swedberg, Phyllis Kramer and the Joiner History Center, John Koach, Ruthmary Woods and Kay Tutor of the Aurora Public Library, Ivan Prall, Ron Lubia of Wolf Camera in Aurora, Carol Sturm of the DeKalb Chamber of Commerce, Elaine Cozort, and Alice Johnson.

Mayor's Welcome

Dear Reader,

Let me introduce you to the history of the city and county of DeKalb, Illinois as documented and written by award-winning author Jo Fredell Higgins.

The city, which is famous for the invention and manufacture of barbed wire, for the opening of Northern Illinois State Normal School on September 1, 1899, and for hybrid corn from the DeKalb Ag, welcomes you. Historian Alistair Cooke has called the years between the Civil War and 1900 as the "golden time of American inventiveness." Time has also given the residents of DeKalb many illustrious ancestors and beautiful historic buildings. The antique and modern photographs in this remarkable book will provide you with many moments of joy and hours of pleasure.

This kaleidoscope of DeKalb's historical memories interwoven with compelling photographs offers an enhancing book to add to your family library. Enjoy these many colors, the seasonal portraits, and the beauty of this "Blossom of the Rose" that is DeKalb, Illinois

Best regards,
Greg Sparrow, Mayor
City of DeKalb Illinois

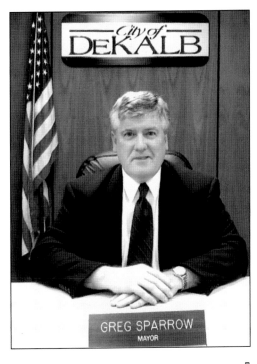

INTRODUCTION

It was 1818. The crews of the boats on the Ohio and Mississippi Rivers were mainly French settlers, who paddled their canoes during the spring and fall seasons. They were in pursuit of deer, fur, and wild fowl, as well as trout, salmon, and carp. They would return home with fur, skins, and feathers. No genuine Frenchman, wrote Governor Thomas Ford of Illinois, in those days ever wore a hat, cap, or coat. The heads of both men and women were covered with Madras cotton handkerchiefs tied in the fashion of night-caps. Their feet had shoes of calfskin or kid slippers. With the pride of dress came ambition, industry, and the desire for knowledge. It is a remarkable fact, however, that they still retained all the suavity and politeness of their race. Ford writes that the "French women were remarkable for the grace and elegance of their manners. They lived lives of alternate toil, pleasure, innocent amusement and gaiety." The houses were generally placed in gardens, surrounded by fruit trees of apples, pears, cherries, or peaches. The United States government was selling land at $2 per acre and $80 for a quarter section.

The history of DeKalb County reflects the achievements of the pioneers who went west and by their courage and personal sacrifices made the area "blossom as the rose," as fortune smiled on them with rich prairie soils, upland timber ranges, underground water reserves, and congenial climate. The pioneer wife picked wool to make the family's clothing, spun and wove flax to make linen goods, and bleached rye to make bonnets and hats. Early social life was centered on quilting, wool-picking, husking bees, and church gatherings. The first white settlers in DeKalb Township were John B. Codius and Norman C. Moore, who arrived in 1835. Formal education began in 1838 in a bass-wood log school house. In 1854, both the Baptists and Methodist congregations built their churches. In 1860, the Catholic church was built and soon the Swedish and Morman beliefs each had a place of worship.

This pictorial journey, replete with scenes of yesterday and today, will show you both the past and the present. Integrity, candor, and intelligence mark the character of the ancestors who built DeKalb. The wagons of corn and provisions, and the pumpkins and coffee that were plentiful for the settlers, have now become available in food centers and shopping malls.

But, oh, to remember it all!

Let us be cheerful and enjoy some merriment as we open the scrapbooks of the past. Our energies are directed to this pleasure, then, and these wonderful reminiscences of DeKalb County, Illinois.

One

BLOSSOM OF THE ROSE
THE HISTORY

"What thou lov'st well is thy true heritage."

–Ezra Pound, "Cantos"

Thomas Jefferson said, "Like Fortune, Nature is profligate with her charms." To the bountiful prairie land and vast stretches of open wilderness came the pioneers. With each Conestoga wagon that made the journey west, imported commodities may have included Irish linens, books and stationery, French chocolate, steel, nails, window glass, coffee, and Hyson tea. In the west, George Washington believed that "an enterprising Man may lay the Foundation of a Noble Estate…for himself and posterity." And so they arrived. The first permanent settler, Jack Sebree of Virginia, raised his log cabin on the banks of Little Rock Creek in the fall of 1834. In February, 1837, Mr. Russell Huntley paid $5,300 to purchase about 500 acres of woodland to the south end of the grove. DeKalb County residents in the 1830s learned from the

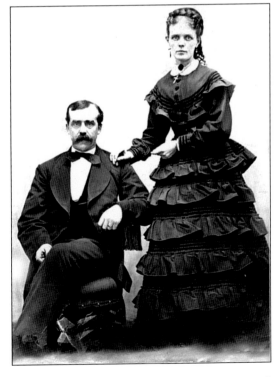

friendly Pottawattomie Indians how to use the axes and skinning knives, pestles for grinding corn, and how to construct log cabins. Early settlers learned their culinary skills, which included cooking game whole and undressed. The sugar was constituted in boiling kettles. Biscuits and butter were diligently made by the women. The fat chanticleer provided eggs and meat. Picturesque DeKalb County, with leafy groves and grassy prairies, welcomed the new settlers. Listening to the prairie wolves howl and the cry of the sand hill cranes, the pioneer family, blithe of spirit and resolve, retired peacefully on each moonlit night.

Sanford Allen Tyler Sr. and Sarah Taylor Tyler on their wedding day on November 30, 1869. Sanford was born in Newark, Tioga County, New York on January 11, 1836. He and Sarah bore four children— Clara Louise, Squire Allen, Harriett Daisy, and Harold Packer. (Courtesy of Helene Reed Tyler.)

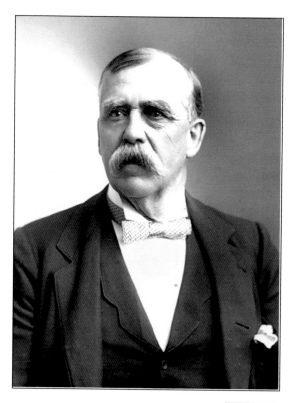

Sanford Allen Tyler Sr., c. 1890s. He served the city and county in a number of capacities, including deputy sheriff, town clerk, and alderman. He was clerk of the board of education for 12 years. Mr. Tyler was a man of sterling character and an honorable and successful businessman. He died on November 14, 1906. (Courtesy of Tyler Family Photos.)

Sarah Taylor Tyler, c. 1890s. She may have taken evening walks with her husband and enjoyed the newly lighted streets. It was October 5, 1891, that John Glidden and S.E. Bradt established the first electric plant in DeKalb. The street lighting was to be turned off at 11 p.m., unless clouds covered the moon. Then they were to burn all night. On moonlit nights, they were not turned on at all. (Courtesy of Tyler Family Photos.)

Baron DeKalb was born on June 29, 1721, in Huettendorf, Germany. An officer in a German regiment that saw service in France, DeKalb emigrated to America in 1768 as a secret agent for the French government, and later returned with LaFayette. Congress had appointed him major general in the Continental Army on September 15, 1777. He died in the battle of Camden during the Revolutionary War on August 19, 1780. When General Washington visited his grave, he remarked, "So here lies the brave DeKalb! The generous stranger who came from a distant land to fight our battles and water with his blood the tree of liberty." (Courtesy of Steve Bigolin.)

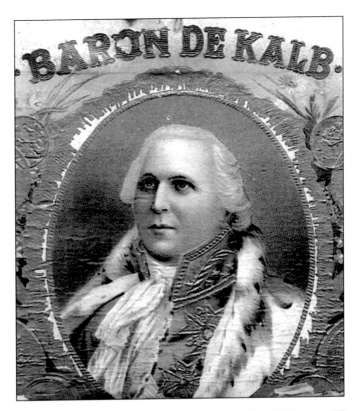

A postcard view of the Kishwaukee River near Normal (NIU) College, c. 1908. The business interests of DeKalb County have been to a great extent agricultural. Great prosperity among the farmers was enhanced by the waters of one branch of the Kishwaukee, along with the timber from an extensive grove bordering this stream, which was known as Huntley's Grove. The first settlers of the township were John B. Collins and Norman C. Moore. They arrived in 1835. (Courtesy Steve Bigolin.)

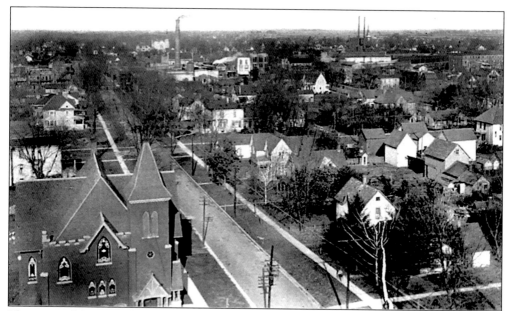

This view of the city of DeKalb was taken around 1900. During this period, the first hospital with 50 rooms was built by Dr. Letitia A. Westgate in Sycamore in 1900. Other energetic women who worked locally for cultural and welfare improvement were Eliza B. Murray, who became head librarian at the DeKalb Library, a position she held until 1928, and Hattie Cheesebro (1875–1956), who was an excellent eighth-grade teacher at the Haish School from 1908 to 1943. An elementary school was later named for her. (Courtesy of Steve Bigolin.)

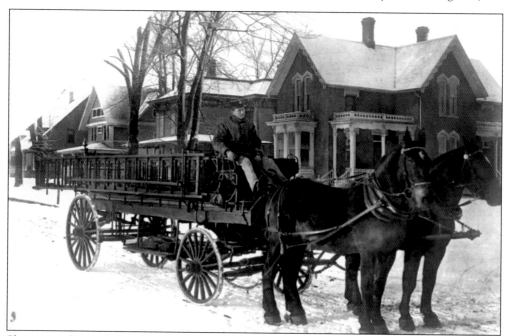

Shown is a horse-drawn fire wagon from the early 1900s at the corner of South Second and Prospect Streets in DeKalb. The first two houses still stand and remain private residences. (Courtesy of Steve Bigolin.)

What a china-doll face on this beautiful baby! Patience Ellwood is pictured with her nurse Amy Sickles in 1912. Her father E.P. Ellwood, president of the First National Bank of DeKalb, was born in DeKalb on August 10, 1873, a son of Colonel I.L. Ellwood. He had wed Miss May Gurler on September 6, 1898. They enjoyed a prominent position in DeKalb social circles. (Courtesy of Ellwood House Museum.)

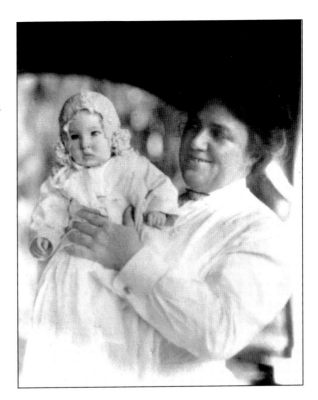

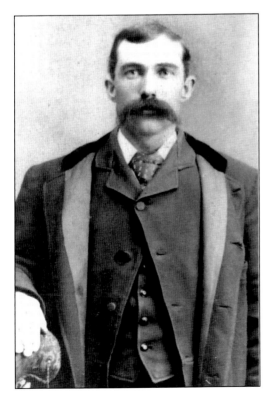

Grandpa Derlin Clapp Davenport, c. 1850s. The population of DeKalb County in 1850 was over 8,000 people. Of this number, 2,280 were born in foreign countries. The pioneers had built on the southern sides of groves with sunny exposures beside the streams. They were hardy people and noted for their neighborly kindness and hospitality. On the fourth day of March 1837 the act for the creation of the county of DeKalb was passed. (Courtesy of Ethel Taylor.)

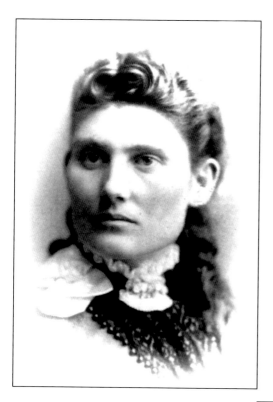

Grandma Annabelle Hunter Davenport, c. 1850s. She lived in one of the first permanent structures in DeKalb County that was made of logs cut at the site. Oak, hickory, walnut, cherry, beech, and sassafras were the hardwoods generally used. Homes were built without nails. The technique of notching held the logs in place. Only the top two logs were fastened with wooden pegs. (Courtesy of Ethel Taylor.)

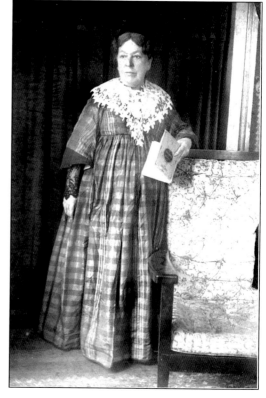

Mary Glidden is seen in her wedding dress in the early 1900s. She belonged to the Young People's Literary Circle, which was organized in 1889 to study American authors. A nucleus of women from this group founded the DeKalb Women's Club. The Women's Club, "showed an active interest in community affairs. They studied and then sponsored such activities as a compulsory education law, street sprinkling, sewage disposal, city health, school playgrounds." (Courtesy of Charles Bradt.)

Mrs. Josiah Willard Glidden, c. 1900s, reading a current best seller. Maybe it was for her paper on American history to be presented to the Literary Circle, or for the next meeting of the DeKalb Women's Club and lecture on the need for school playgrounds. It was May 29, 1896, that the Women's Club was formed, with dues at $1.50 a year. The first meeting was held at the home of Mrs. John Taylor, with 27 ladies present. Jane Addams spoke in DeKalb on December 10, 1904, and was paid $50. In later years, the group sent money to support restoration of Hull House. (Courtesy of Charles Bradt.)

Grandma and Grandpa Derlin Davenport, c. 1890s, in their garden. She may have been picking flowers for the Altrusa Club's flower and fashion show. Other money-raising events included the sale of a *Better Homes and Gardens* book and contributions to community groups, such as "Safe Passage." (Courtesy of Ethel Taylor.)

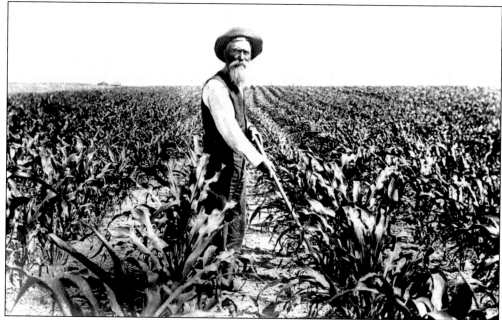

William H. Davenport, August 5, 1908, using a hoe in his fields. In 1870, the value of factory output in DeKalb County was $250,000, which was small compared to the $2.9 million in farm produce. Soil improvement, production of high-quality seed corn by the DeKalb Corporation, John Deere's invention of the steel plowshare, the Marsh brothers' harvester, and the McCormick reaper all changed the pattern of farm labor. (Courtesy of Ethel Taylor.)

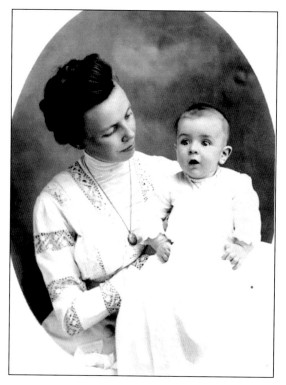

A photo of Alice Baldwin, c. 1900s. It was 1900 when L. Frank Baum wrote *The Wonderful Wizard of Oz* and Eastman Kodak began selling a $1 Brownie camera. The first electric typewriter went on sale in 1901. And in 1904, a woman was arrested in New York for smoking in public. (Courtesy of Ellwood House Museum.)

Jessie Glidden and Gladys Davenport sit for a lovely portrait, c. 1920. Elaborate rules posted by NIU's first dormitory in 1916 imposed a 7:30 p.m. curfew on weeknights and a 6:45 a.m. rising bell. The piano was not to be played before noon. Ragtime and other popular music were not allowed on Sunday afternoons. Gentlemen visitors were to be entertained in the living room only. The telephone was not to be used in the evening after study hours. (Courtesy of Ethel Taylor.)

The compelling faces of DeKalb's young women, c. 1880s, by Oleson Photography. Earlier that day they had been surprised by a new invention called the cash register, which had been invented in 1879 by James J. Ritty. He had wanted to prevent stealing from his tavern customers. (Courtesy of Ellwood House Museum.)

Charming girls, *c.* 1880s, barely smile in this photograph. They were disappointed, perhaps, because they did not have a telephone at home! Ithamer Robinson went to Chicago on September 20, 1879, to inquire about a telephone line installation from DeKalb to Sycamore. Telephone installations were news in those days. (Oleson Photography, courtesy of Ellwood House Museum.)

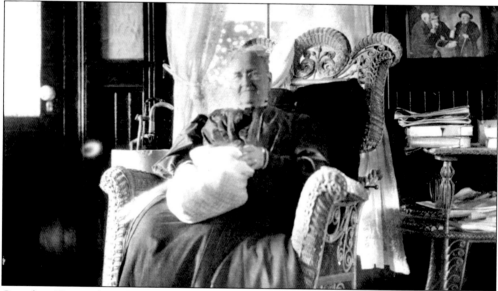

Grandma Harriet (Isaac) Augusta Ellwood in her sitting room in her house in Florida, *c.* 1906. It was 1904 that the tea bag was introduced in the United States. And the Parisian jeweler Louis Cartier invented the wristwatch that same year. Do you suppose that she enjoyed her afternoon Earl Grey tea in that room? Did she wear a silver wristwatch? The Ingersoll silver filigree watch cost $1 at that time. (Courtesy of the Ellwood House Museum.)

The dresses look so decorative! In an essay on "Desirable Characteristics of College Males," the author suggested that men pay attention to their appearance, intelligence, and manners. They could also "drive about in the snappiest roadster, learn to say nice things to his girl and be easy to get along with." They should be the "answer to a maiden's prayer." Another photograph by Oleson Photography, c. 1880s. (Courtesy of Ellwood House Museum.)

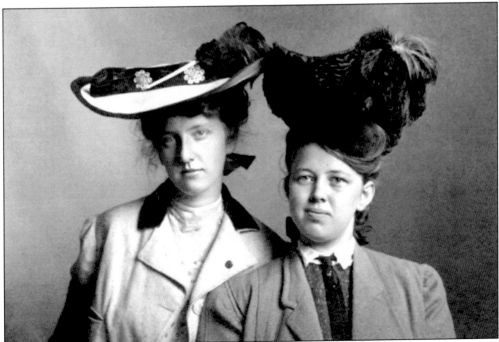

Hats make a fashion statement for Ethel Jackson Brown and her best friend in the early 1900s. Hats could show a cascade of ribbons, decorated with combs, lace scarves, or ostrich feathers. A stylish hat made a statement of self-esteem, rank, and elegance. (Oleson Photography, courtesy of Ellwood House Museum.)

A most attractive couple in the 1890s! The lady is Genevieve Gallagan. They may have eaten apples from Eli Barnes' orchard. He was the first to plant the Vermont seeds on his farm, in section 1, in 1839. (Courtesy of Ellwood House Museum.)

Belle Pearl Barnes with daughter Louise, c. 1900s. In 1884, DeKalb Township had listed 21,539 acres of improved land, valued by the assessor at $343,265. Some of the items of personal property listed included 262 sewing and knitting machines, 46 pianos, 95 organs and melodeons, 11 steam engines, 1,084 horses, 2,587 cattle, 343 carriages and wagons, 448 watches and clocks, and 21 safes. (Courtesy of Ethel Taylor.)

Two

TO RIDE IN THE WHEELBARROW

"Nothing that is can pause or stay; The moon will wax, the moon will wane, the mist and cloud will turn to rain, the rain to mist and cloud again. Tomorrow be today."
-Henry Wadsworth Longfellow

The County of DeKalb, early 1800s, was the home of the Indian. Supported by the Indian agent in Chicago, they had authorization to drive off any white man who should encroach upon that land. With the Indian movement to the west, record numbers of white settlers arrived. A Frenchman was probably the first European to arrive in DeKalb County. It is likely that French fur traders, who were known as *Courier du Bois*, came by means of the rivers. They traded with the Indians and coexisted with them. In pre-empting and claiming land, the immigrant would camp nearby a favorable grove and stream. He would mark a tract of land by blazing the trees. Thus, he had a right to hold that parcel of land until government surveying would give him a title after purchase from the United States government. Some of the more intelligent and enterprising of eastern society settled in the County of DeKalb. The frontier society welcomed men and women of polish and elegance. By 1840, all of Illinois had been settled, except for some patches of wide prairie land. With the settlers came their religion, as well as literature. Churches were established and the "church-going bell" began to be heard. With the advent of the railroad in 1853, merchants found that the stack of goods they could sell had increased. Credit was extended at a 12 percent interest rate. The Schaab family mercantile business was operational from 1877 until 1975. Its "suit club" drawings were a popular event on Saturday nights for several decades. Peddlers would push wheelbarrows throughout the county selling their wares. Butter, chickens, and eggs were exchanged for those products.

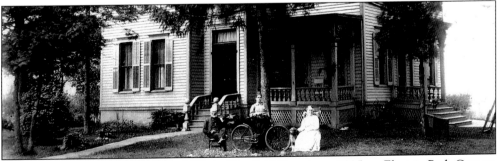

Shown is the home of Gurdon and Edith Chatfield Dennis, *c.* 1895, at Electric Park Corners on Sycamore Road. Enjoying a late summer day with them is their daughter Grace. Nature whispers with a symphony of translucent flower petals and soft winds smiling. Nestled beneath the old oak tree sit dandelions and daisies. (Courtesy of Barbara Wallin.)

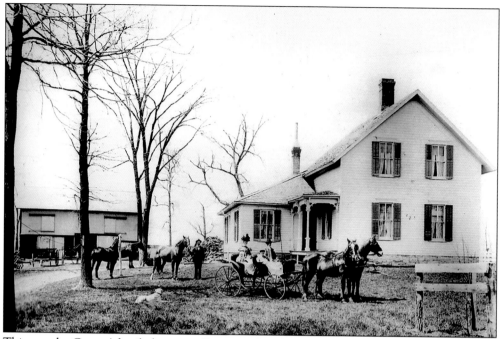

This was the Groves' family home on Sycamore Road, 1897. Sitting in the carriage are Henry and Annie Groves and their children, Dallas and James. (Courtesy of Barbara Wallin.)

The poet Longfellow wrote, "And the song from beginning to end, I found again in the heart of a friend." This photo of Jean and sister Elise Ellwood, c. 1895, illustrates this quote quite nicely. They were the daughters of William Ellwood, son of Isaac L. Ellwood. (Courtesy of the Ellwood House Museum.)

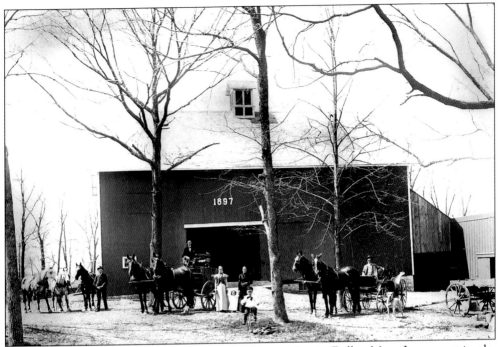

Shown in front of the new barn, 1897, are Joe Groves, Annie, Dallas, Mary, James on tricycle, father Henry in the carriage, and their watchful dog. (Courtesy of Barbara Wallin.)

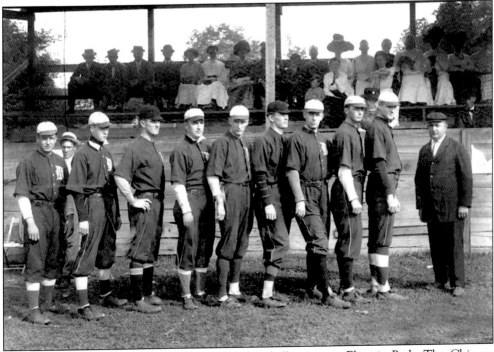

For the sport enthusiasts, there were weekly baseball games at Electric Park. The Chicago White Sox played an exhibition game on its field. Shown here is the owner Henry Groves with his baseball team in front of the grandstand. (Courtesy of Barbara Wallin.)

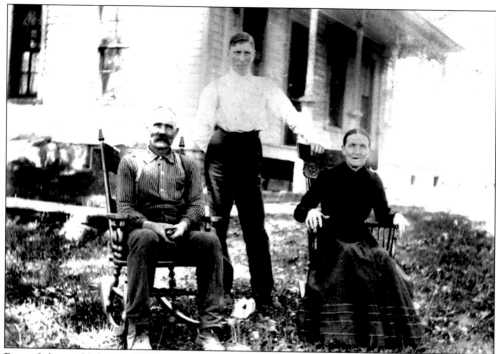

Bengt John and Johanna Wallin enjoy their rocking chairs with son Harry Wallin, c. 1907. The Boy Scouts was founded in 1907, so Harry's friends might have joined the group later on. His cousins could not have joined the Girl Guides until 1912. Juliette Gordon Low founded the organization on March 12, 1912, and it later became the Girl Scouts of America. (Courtesy of Barbara Wallin.)

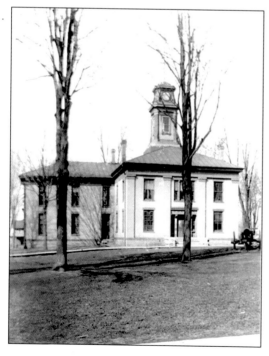

This photograph shows the second DeKalb County Courthouse. The third DeKalb County Courthouse was built in Sycamore, Illinois, in 1904–1905, at a cost of $175,000. The exterior is constructed of Indiana limestone and when it was new the building was referred to as a "temple of American architecture." In 1978, tinted windows were installed. The DeKalb County Soldiers' Monument was erected on the grounds in memory of the heroes in the Civil War. The interior, including floors, staircases, and wainscoting, is built with southern marble. The ornamental work is in green bronze. A February 1906 report noted that the town of Sycamore had interurban streetcar service, gas, electric light and power, a public steam heating plant, and an up-to-date electric system of fire protection. (Courtesy of Barbara Wallin.)

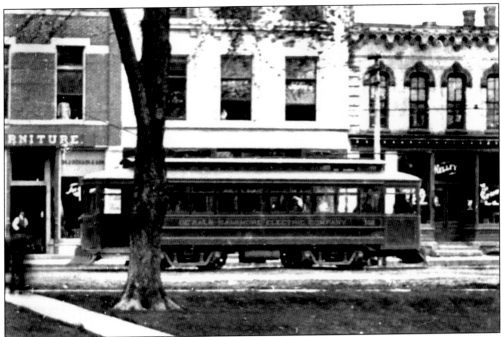

The electric trolley streetcar is shown on Main Street in Sycamore, in front of the courthouse. It began service in December 1903 and the firm closed on April 17, 1924. The equipment consisted of three passenger cars, the combination work and sweeper car, plus a number of open summer cars. With the advent of the automobile and bus service the company had ceased making a profit on the venture. (Courtesy of Barbara Wallin.)

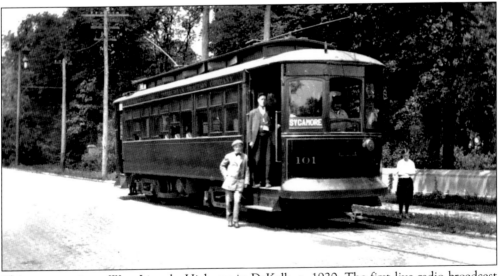

This streetcar is on West Lincoln Highway in DeKalb, c. 1920. The first live radio broadcast aired in Pittsburgh this year. The 19th Amendment was ratified, which gave women the vote. Prohibition began and ushered in bootleggers, gangsters, and speakeasies. Modern conveniences included telephones, automobiles, jazz, and movies. The booming economy of the 1920s brought with it a national euphoria. This ended on Black Thursday, October 24, 1929. (Courtesy of Barbara Wallin.)

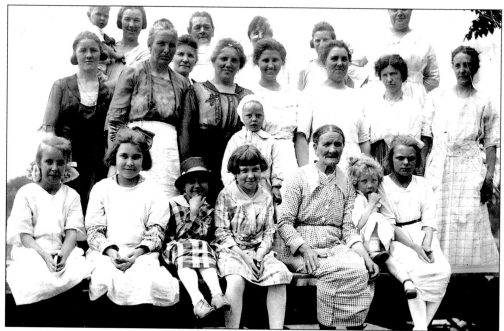

The Wallin family gathered all the women for this photograph in 1918. In the first row, third from the right, sat Grandma Johanna Matson Wallin. She was born in Helland, Sweden on June 22, 1848. She wed Bengt Wallin and they both came to America on August 28, 1882. They farmed in DeKalb County and Mrs. Wallin spoke only Swedish until her death on April 14, 1938, at the age of 90. She was survived by two sons, two daughters, fourteen grandchildren, and fifteen great grandchildren. Three children preceded her in death. I would have liked to have known her! (Courtesy of Barbara Wallin.)

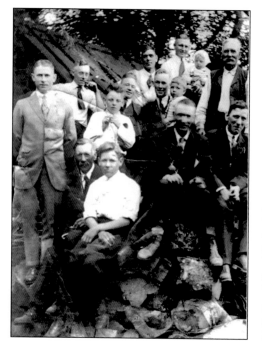

The men pose by the woodpile at the Wallin family reunion in 1918. Grandfather Bengt John is standing in the upper right of this photo. Notice the suits and ties for such an outdoor gathering! They may have received an airmail letter that year. Airmail stamps became available as Army pilots began the first permanent "aeroplane mail" service. The first official stamp, showing a biplane in flight, was printed upside down—thus it became a collector's item. (Courtesy of Barbara Wallin.)

Two boys, in all their finery, pose for J.O. Oleson Photography in the early 1900s. See the straw hats! What a counterpoint of yellowed hay and fancy clothing is shown! Did they have condensed soup for lunch? It had been invented in 1897 by chemist John T. Dorrance. When composer Giuseppe Verdi (1813–1901) needed inspiration, he had a bowl of noodle soup! (Courtesy of the Ellwood House Museum.)

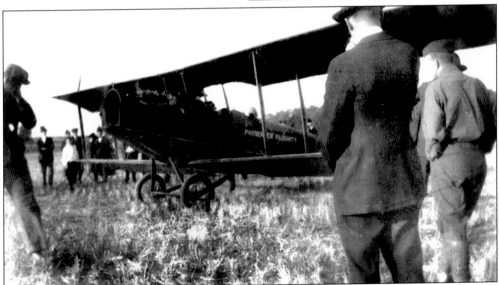

A single motor plane landed on the north side of Electric Park in the pasture about 1915. In a restricted report issued to the Bureau of Aeronautics, U.S. Navy Department, in 1942, the Rudolph Wurlitzer Co., a DeKalb division manufacturer of pianos and accordions, was chosen to be the assembly location for the new radio-controlled war planes. Wurlitzer supplied most of the parts for assembly. Motors and other vital parts were shipped to DeKalb. Peacetime employment at Wurlitzer had been about 1,000, with half of that labor force female. The first airfield and hanger were then built in DeKalb, so that the new twin engine, a pressed-wood type plane with tricycle fixed landing gear, could fly to a military field. (Courtesy of Barbara Wallin.)

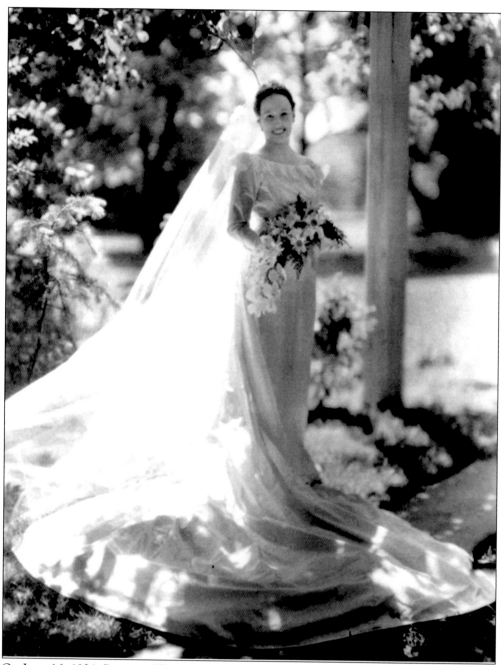

On June 16, 1934, Patience Ellwood Towle smiled for this exquisite wedding day photograph on the grounds of Ellwood House. A more splendid wedding photograph would be difficult to imagine. The shadows and the light play together to fashion a mosaic masterpiece. Her father, Erwin Perry, and mother, May Gurler Ellwood, celebrated with great happiness on this day. In a 1981 recollection, Patience wrote that "My little world was centered around 'Ilehemwood' which is now the Ellwood House. My dollies and I played for hours in the little house. I loved making May baskets and filling them with flowers from the woods at the farm and candy that our nurse Mamie had made." (Courtesy of Ellwood House Museum.)

J.O. Oleson, photographer, DeKalb, Illinois took this winsome photograph of Clara Louise Tyler in 1890. (Courtesy of Tyler Family Photos.)

James Sharp Rankin, M.D., *c.* 1897, is shown in a serious pose. He had come to DeKalb in April, 1897, and located his practice at 157 East Main Street. On March 30, 1898, he wed Miss Clara Louise Tyler, who was born in DeKalb in 1870. Dr. Rankin held the positions of district surgeon for the Chicago & Northwestern Railway Company, local surgeon for the American Steel & Wire Company, physician to the DeKalb County poor farm, and was examining physician for the New York Life, Equitable Life, and Mutual Life Insurance Companies of New York (Courtesy of Tyler Family Photos.)

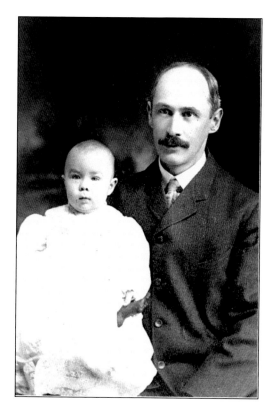

Pictured are Dr. James Sharp Rankin and his son, James Tyler Rankin—whose natal day was May 7, 1906. Dr. Rankin was born in Plainwell, Michigan on April 15, 1871. He graduated from the Chicago College of Pharmacy in 1890 and received his medical degree from Northwestern University Medical School in 1895. He was known to have had a shrewd and careful mind, and a disposition that was mild in manner. (Courtesy of Tyler Family Photos.)

In 1895, Clara Louise Tyler (1870–1952) smiled tenderly for the camera. Three years later, Clara would marry J.S. Rankin, M.D. on March 30, 1898. (Courtesy of Tyler Family Photos.)

Baby Wilbur Blair, *c*. 1918, is shown in a glorious photograph! (Courtesy of Ethel Taylor.)

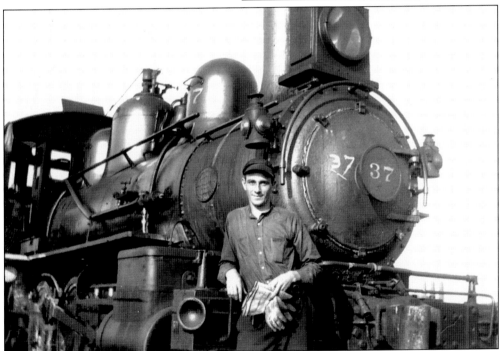

The Galena and Union Railroad was the first to enter DeKalb on August 12, 1853. In this photo, Harry Horton stands before the #37 engine in DeKalb, Illinois. It was 1920. Long before that, a resident could see transcontinental freight roll by. The *DeKalb News* noted on September 19, 1871, that "An immense tank, with a capacity of at least 50 barrels, passed eastward Monday morning. It was labeled 'Allyne & White's Pacific and Atlantic Oil Express' and was going seaboard to be filled." (Courtesy of Ethel Taylor.)

Helen and Ethel Horton, c. 1920s, embrace one another. American-born Lady Astor had been elected the first female member of the British Parliament the previous November, 1919. "Fair on earth shall be thy fame, as thy face is fair," seems appropriate for each of them. (Courtesy of Ethel Taylor.)

Gladys Davenport, bottom, and her friend c. 1915. The large hats were popular at this time. I wonder if they were made at The Hat Shop in Genoa? Owner Annette Duval was the wife of a Methodist preacher. The store's balcony extended over the Duval Meat Market. (Courtesy of Ethel Taylor.)

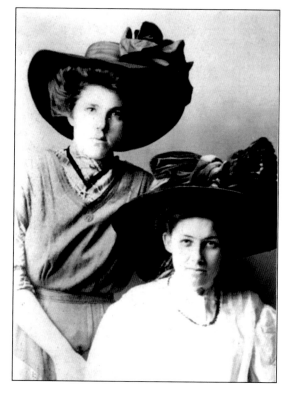

Three

THE MERCANTILE BUSINESS

"He that invents a machine augments the power of a man and the well-being of mankind."
–H.W. Beecher, 1887

In 1894, the editor of the *Chronicle* wrote that, "DeKalb is the largest manufacturing center in the west in proportion to population," and a year later continued by saying that, "DeKalb County has fertile soil, nearness to markets, its churches, schools, its beautiful women, good society and in all other things that go to make up the sense of human happiness, it is doubtful if DeKalb County is excelled anywhere in the world." Businesses and services included meat markets, milliners, hardware stores, bakeries, plumbing, and tin merchants. There were jewelers, taverns, billiard parlors, confectionaries, barbers and hairdressers, restaurants, and a hotel. "Barb City" became known as the birthplace of a new type of fencing material, that in time would help settle the west. Joseph F. Glidden perfected a form of barbed wire that would become the standard for manufacturers and consumers throughout the world. The basic Glidden patent still governs most wire production today. In 1886, Glidden's The Barb Fence Company produced 44,000 tons. No wonder he was called "the grand old man of DeKalb County." Jacob Haish, a DeKalb lumber dealer, developed simultaneously in his shop an "S" type barb that competed with Glidden for years. Isaac L. Ellwood, a hardware merchant in DeKalb, also invented a style of fencing, but realizing that Glidden's patent was superior, purchased a half interest from Glidden for $265—which was at that time half of Glidden's expenses!

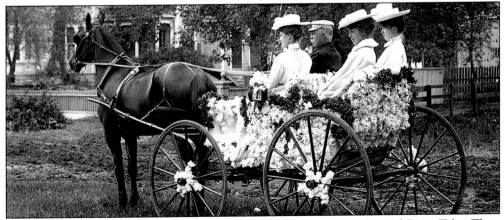

Shown are S.A. Tyler Sr., wife Sarah, and their daughters Louise Tyler and Daisy Tyler. Their carriage is decorated for the NIU Crimson Days Parade in 1899. In the Crimson Days parade, Jessie Ellwood, Isaac's daughter, served as queen. (Courtesy of Tyler Family Photos.)

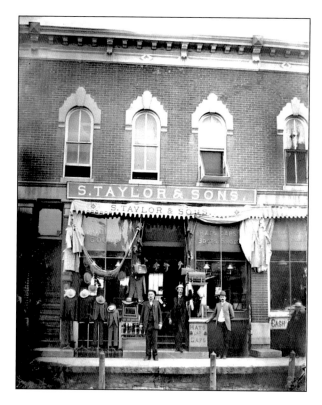

This rare tintype shows the proprietor and staff in front of the S. Taylor & Sons shop, where hats, caps, boots, and other clothing were sold. Note the hitching posts for horses on the street. (Courtesy of Tyler Family Photos.)

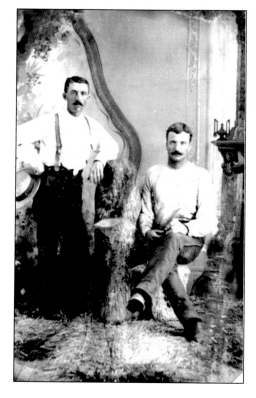

In 1890, John Glidden and a friend posed for this photograph. Many of their contemporaries bought their clothing from James O. Bjorkman, a Swedish clothing merchant in DeKalb. Other respected citizens included August Wilhelm Stark, who was the pastor of the Swedish Lutheran Church. Another Swede, John F. Johnston, had been musical director of the Third Regiment Band. Simon Johnson, inventor, manufactured his chimney staging and ladder hanger inventions himself. Nels J. Smith was a farmer and Samuel Peterson was foreman at the DeKalb Implement Works. (Courtesy of Jessie Glidden.)

Pictured, from left to right, are Augusta Gracie Everett, Aunt Louise Tyler Rankin, and an unidentified friend as they sit pensively for the camera. I wonder what they were thinking. Had they just taken an afternoon stroll down Augusta and College Avenues? The American elm trees there had been planted by Grandma Harriet Augusta Ellwood (1837–1910). (Courtesy of Jessie Glidden.)

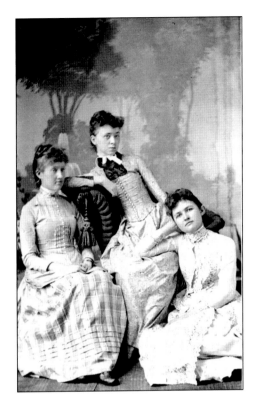

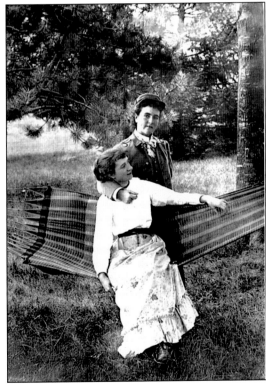

Mabel Carter, a Glidden cousin, and her beau are enjoying the hammock on a lazy summer's day. They have finished their picnic of roasted pork sandwiches, cold cucumber salad, and cherry tarts. (Courtesy of Jessie Glidden.)

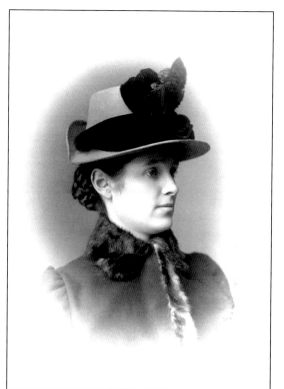

The name of this lovely woman of generations ago is unknown. Her chapeau is delightful and her complexion smooth as a newborn. Her hair has been braided. By whom? Let us conjecture that her husband had offered to braid her hair for this photograph! And now, so many generations later we look fondly on her and can only smile with appreciation. (Courtesy of Jessie Glidden.)

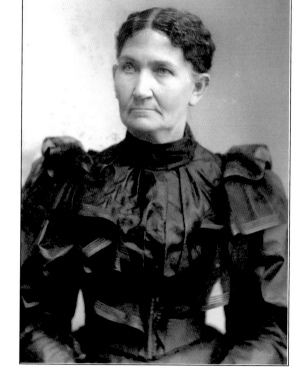

In 1896, Huldah White Carter, Jessie Glidden's grandmother, put on her Sunday finest and looked so serious when the camera caught her attention. The silken folds of the dress suggest a flowing movement that counterpoints the seemingly rigid pose. (Courtesy of Jessie Glidden.)

Pictured, from left to right, are Eva Embre, Mrs. Rosette, Mrs. Rowley, Angie Quinn, Mrs. Knodle, and a friend enchanting us with this scene. It was 1919, and the jazz era was in full swing. AT&T introduced the first dial telephones, and in some states phone numbers could be dialed without the aid of an operator! Transcontinental airmail service between New York and San Francisco would begin next year. (Courtesy of Sally Stevens.)

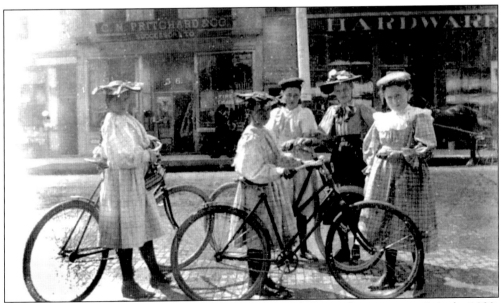

Vera and Hazel Wiswall and friends stop on Lincoln Highway to glance our way. It is the 1930s and the girls rode their bicycles to town to shop for licorice and new lace socks, and to see the movie at the Egyptian Theatre. Scotch tape, 7-Up, vitamin pills, and the electric razor were introduced this decade. The words in vogue in the 1930s included fireside chat, New Deal, swing, jitterbug, and dole. (Courtesy of Sally Stevens.)

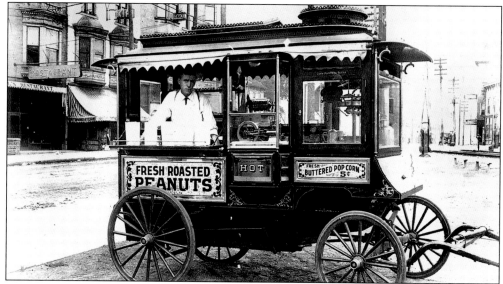

In 1904, this carriage shop sold hot buttered popcorn and fresh roasted peanuts, as well as fresh lemonade and candies. Molasses candy kisses cost 5¢. At Oblander's Drug Store, a big chocolate soda was the preferred treat. With a 15¢ allowance, the children saved 5¢, put 5¢ in the offering plate at church, and spent the remaining 5¢ going to the Saturday movies. (Courtesy of Sally Stevens.)

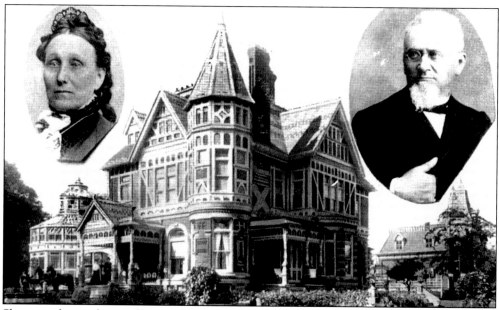

Shown is the residence of Mr. and Mrs. Jacob Haish, with inserts of their photographs. Jacob was born on March 9, 1826, in Germany. His imposing home was built with the fortune earned from the manufacture of barbwire. By 1895, as many as 157,000 tons of barbed wire were manufactured per year. Glidden had sold his half interest rather early, leaving Ellwood and an eastern partner to form a new company. The wire producers were finally merged into what became known as the American Steel & Wire Company. In 1901, it became a subsidiary of United States Steel Corporation. (Courtesy of Sally Stevens.)

Pictured, from left to right, are Cornie, Rachel, Tom, and Olive Olsen in the 1930s in DeKalb. In 1934, the first corn sales were made by the DeKalb Ag Association. In 1937, Nescafe', the first commercially successful instant coffee, was made by the Swiss Nestle' Company. Disney issued *Snow White and the Seven Dwarfs*. It was the first all-color cartoon feature film with sound. (Courtesy of Sally Stevens.)

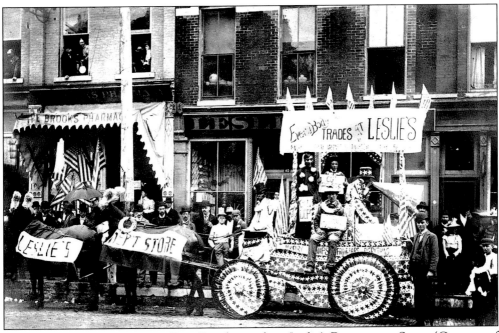

Another entry in the Crimson Days Parade was from Leslie's Department Store. (Courtesy of Sally Stevens.)

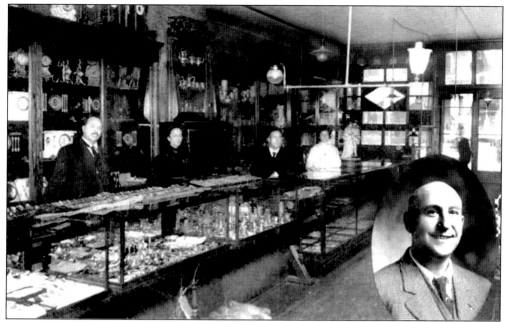

Shetter Jewelry was located at 214 East Main Street in DeKalb. (Courtesy of Sally Stevens.)

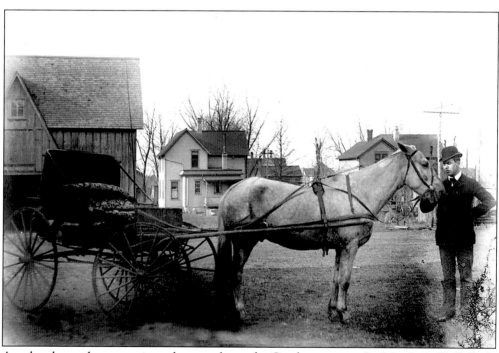

Another horse-drawn carriage about to leave for Sunday mass at St. Mary's in DeKalb. It is 1923. *Time* magazine was first published this year. Founded the previous year, the BBC introduced daily weather forecasts. The Charleston dance craze swept America and the candy bars Milky Way and Butterfinger appeared. (Courtesy of Charles Bradt.)

Grace and Maude Mungar are shown in this 1930s photograph. Scotch tape was invented in the United States in 1930. In 1931, J. Schick marketed the electric razor and Alka-Seltzer made its appearance. In 1938, NIU had 900 students crowding its campus. Barbed wire and other steel products were made in DeKalb until May 1938, when the American Steel & Wire Company moved to Joliet and Waukegan. (Courtesy of Sally Stevens.)

Aunt Ann Goodenow is seated in the center, front row, with John, Flora, Charlie, Nett, and Ira beside her. The heavy brocade wallpaper was very popular during the Victorian era. Books and magazines devoted to interior decoration, fashion, and housekeeping were now available. Women who labored outside the home were still expected to bake bread for the family and do the washing and housekeeping. (Courtesy of Sally Stevens.)

Anne Eddy Smith enjoyed dancing at a very young age. She would later found the Stage Coach Theatre. The first home of the Players was the loft of John Ellwood's barn on North First Street road. The box office was a borrowed Ellwood carriage that inspired the name "Stage Coach Theater." Under the direction of Anne Smith Grey, a melodrama entitled "Pure as the Driven Snow" opened on a cold March night in 1947. Anne's parents were Mary and Earle Smith. (Courtesy of Sally Stevens.)

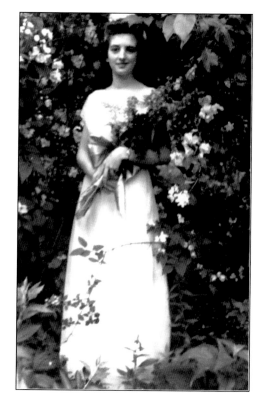

In 1942, Norma Clapsaddle Smith was a bridesmaid for Anne Eddy Smith Gray. This luxurious photograph reminds me of the phrase "Quand le soleil dit bonjour aux montagnes, et que la nuit rencontre le jour," which translates to "Now when the sun says hello to the mountains, and the night says hello to the dawn." That would have been when bride and bridegroom began their new life together. (Courtesy of Sally Stevens.)

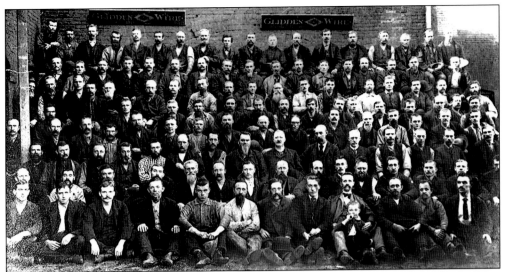

On September 14, 1937, the employees of Glidden Wire Company posed for this picture. Founder Joseph Glidden had served as sheriff, mayor, vice president of the DeKalb National Bank, director of the Northwestern Railroad, and owner of the DeKalb Rolling Mill. He bought the *DeKalb Chronicle* in 1879. Other Glidden inventions included a unique gate-locking device, a pump, a horse collar, a fastener for horse bridles, and a special kind of glove. Dun and Bradstreet recorded his assets at one million dollars in 1895. That also included the Glidden House Hotel, 3,000 acres of farmland in Illinois, 335,000 acres in Texas, and the Glidden Felt Pad Industry. (Courtesy of Sally Stevens.)

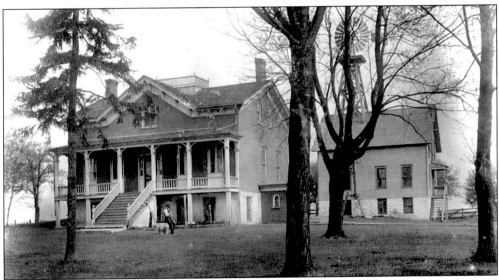

The Annie Glidden House on Glidden Road as it looked in 1938–1939. Nylon stockings and nylon toothbrushes were first manufactured in 1938. In 1939, Hollywood premiered *Casablanca, Gone With The Wind*, and *The Wizard of Oz*. In 1940, rapid expansion of production facilities and a superb sales force moved DeKalb to the top in seed corn sales. The DeKalb truck manufacturing company, that made DeKalb's third fire truck, changed its name to DeKalb Commercial Body Company and began to specialize in the manufacturing of truck bodies. (Courtesy of Jessie Glidden.)

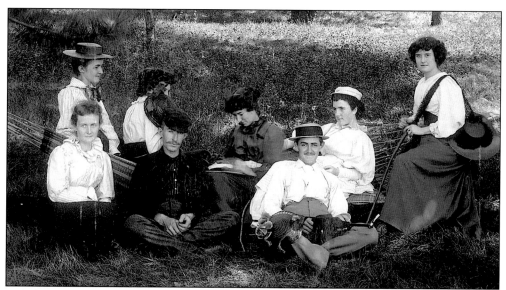

Mabel Carter Glidden is wearing a straw hat in the left back of this photo. The other companions are not identified. It is the 1890s and the group has just returned from a church social. Box lunches were sold for as much as $10 and the money was used to purchase library books. (Courtesy of Jessie Glidden.)

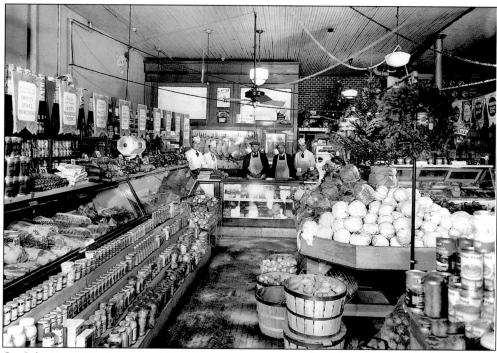

On July 29, 1922, Anton and Ika Kovaceric arrived at Ellis Island Immigrant Station from Croatia. Ellis Island had formally opened in 1892. He soon shortened his name to Anton Koach. This is his supermarket on East Lincoln Highway in 1936. His son John (1925–1998) was a CPA in DeKalb. Anton's grandson is Anton James Koach, a CPA in DeKalb. (Courtesy of John Koach and Helene Reed Tyler.)

Four

FAMILY LIFE IN DEKALB COUNTY

"Stand by the road, and look and ask for the old paths, where the good way is and walk in it and find rest for your souls."

-Jeremiah

Emerging from the pristine prairie, the settlers of the mid-1800s drove their wagons, with four yoke of oxen, into the clearing by the Kishwaukee River. Tall white oaks stood as sentinels to greet them. Noted Indian chief Wau-ban-se had been hunting in this area earlier. These hardy pioneers soon established sawmills along the riverbanks. As fast as lumber could be manufactured, it was used to build their homes. On March 11, 1837, the act for the creation of DeKalb County was passed. Pioneers from New York and New England soon established private schools and religious societies here. The year 1840 yielded an abundant harvest. Grain was hauled to Chicago by ox

teams and was sold for 20–40¢ a bushel. A stage route from St. Charles to Sycamore was begun in 1840. An elegant four-horse coach carried the passengers over the old state road, a distance of 55 miles. In 1850, the first schoolhouse was built. It was 14 x 14 ft. and the seats were made of split logs. Jonathan Stone was the first teacher. In 1884, the teacher's salary was listed as $122.22 per month. There were 765 children enrolled in the public schools. The first gristmill was built by 1853 by Mr. Brooks. In 1860, the first Catholic Church, St. Mary's, was built, which was occupied for over 40 years.

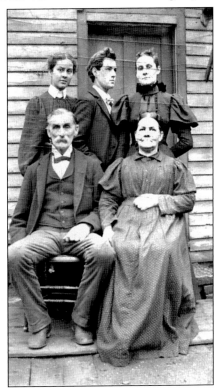

An unidentified family sits by their front door in this 1890s photo. A memoir written by Laura Bowers in 1902 described Chief Shabbona (1775–1859), who had lived in the southwest quarter of section one of DeKalb Township until 1857. She wrote, "Shabbona was generous with the white people. He would bring a quarter of venison to his neighbors and once in a while a wild goose or a duck. While the Indian men hunted, the squaws did the woodcutting. Squaws had to keep the fires in the wigwam and cook the succotash, corn and beans." It was noted that the chief could only sign his name with an "X." (Courtesy of Sally Stevens.)

Zilla Gurler's photograph shows a rather imposing matriarch. Her home was located on the southern side of the groves beside the streams and springs. Her family was of hardy stock and noted for their neighborly kindness and hospitality. Many pioneers who came in 1835 left no record of their stay in DeKalb County, but chose instead to continue westward. (Courtesy of Sally Stevens.)

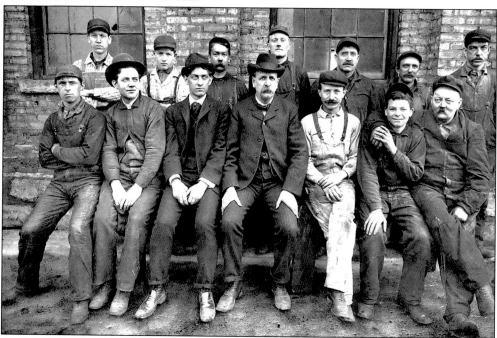

A group of DeKalb workers on an autumn's day, c. 1920s. John Logie Baird invented the television in 1925 and in 1927 *The Jazz Singer*, the first "talking picture," was released. Babe Ruth hit 60 home runs in the 1927 season. History also records that Babe Ruth struck out 1,330 times. (Courtesy of Sally Stevens.)

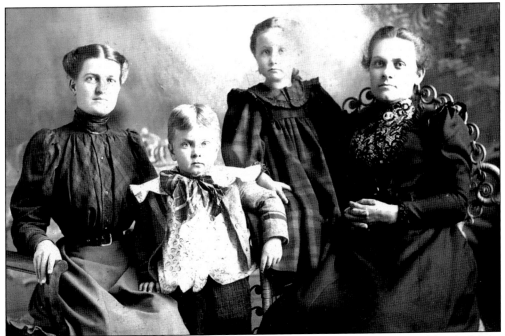

Faye, Henry, Esther, and Rose Smith remind us of the beauty and harmony of family life in the 1920s. Each one has a languid smile as they touch one another. Had they been listening to the RCA red seal recordings on their Victrola? Had they enjoyed the voice of Caruso on those original thick wax discs? (Courtesy of Ethel Taylor.)

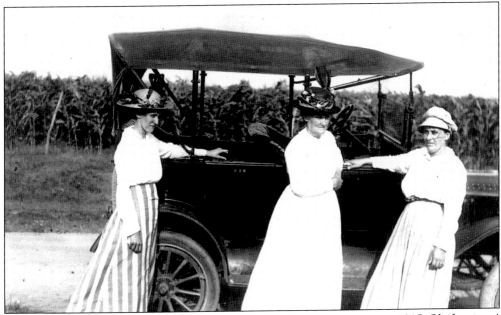

Gladys, Jessie, and Annabelle Hunter Davenport stop for a brief moment in 1915. Oh the times! Women wore hats and dressed in beautiful fabrics. White shoes were polished to perfection and matched the white gloves worn during this era. And one mark of a lady was "arranging flowers beautifully." (Courtesy of Ethel Taylor.)

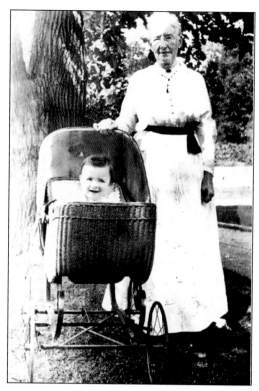

Mrs. Atkinson and Buddy Tyler are enjoying the June afternoon together. Buddy is wearing blue because it was believed that this color would prevent evil spirits from entering the bodies of male children. Blue was chosen because it's the color of the sky and was therefore associated with heavenly spirits. Pink for girls was popular because of an old English legend which said that girls were born inside of pink roses. (Courtesy of Sally Stevens.)

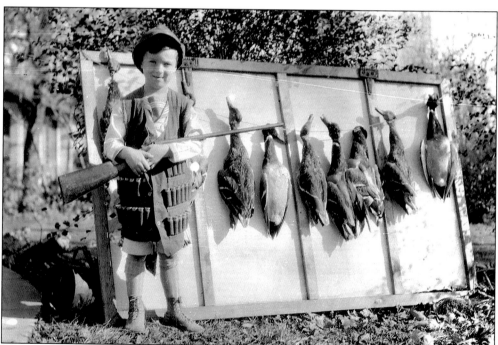

Buddy Tyler, c. 1920s, with his catch of ducks. This was a harbinger of things to come, because as he grew up Bud developed quite a skill and interest in carving duck decoys. As Fyodor Dostoyevsky wrote, "Only the heart knows how to find what is precious." (Courtesy of Sally Stevens.)

Hazel Rolfe shows us a filmy, gauzy look in this engaging photo. A whimsical hint of a smile shadows her face. What thoughts brought her expression? Had she just read a letter to Mrs. Gilbert that said, "Our parlor is warm without extra fire. My dear, wonte you be so good and kind as to lend a helping hand with our quilt?" That letter was signed, "Yours with everlasting respect, Mrs. J.F. Glidden." (Photo courtesy of Sally Stevens.)

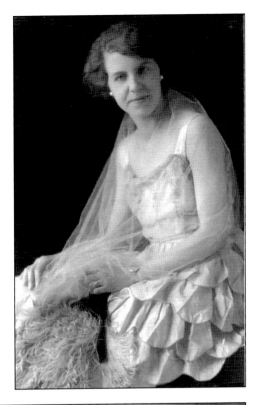

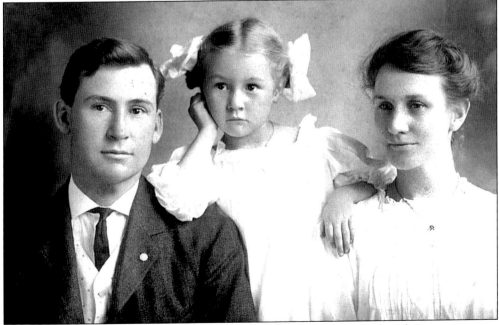

This unidentified family photo is delightful! "Well, Daddy," says the little girl, "are we going to shop for my new bicycle today?" Mom is smiling because she knows that the birthday gift for their daughter is already waiting at home. Turning five years old was important to all of them this day. And it was captured for our joy with this photograph. (Courtesy of Sally Stevens.)

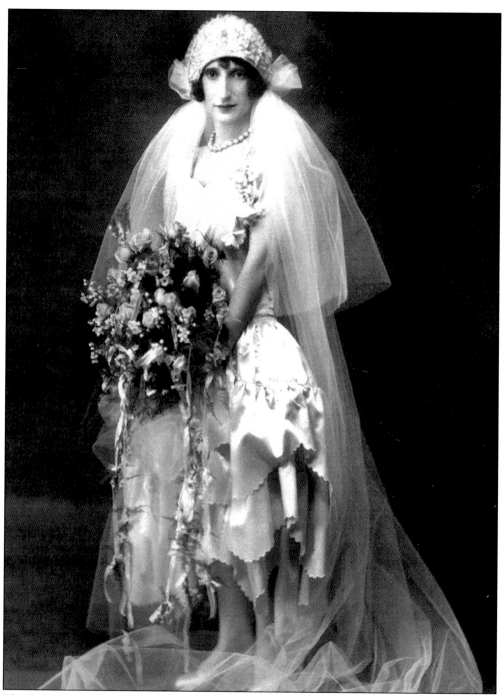

This bride, Mrs. Julius Greenberg, just astounds me! Her head is covered with a beaded cap, flowers in profusion hanging down, petals of satin forming the skirt, and white stockings are seen amid the long train of netting. Did her two best friends write an epithalamion, their nuptial song or poem on this day of April 21, 1929? How many children would she bring into this world? Was her husband faithful, supportive, and attentive? (Courtesy of Joiner History Center, Phyllis Kramer, Sycamore, Illinois.)

Another majestic photograph of an unidentified woman, c. 1910. Would she have danced the tango that swept both the United States and Europe this year? Did she ever put iodine on a scrape—it was introduced in 1910. Were her days filled with her children's play and did she have a loving husband? (Courtesy of Charles Bradt.)

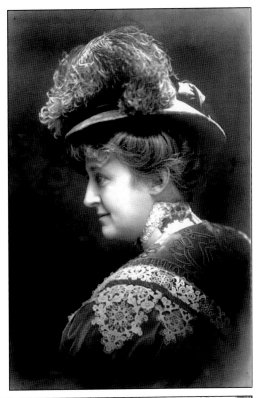

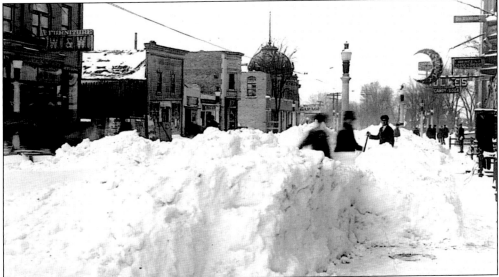

This was a scene in 1915 on Lincoln Highway after a major snowstorm. A horse-drawn sleigh ride was punctuated by bitter gusts of wind and swirling snow. Fairy tales in Germany and Holland explain snowflakes as feathers that Holle, the Queen of Winter, shakes out of her mattress. Ice skating on the frozen Kishwaukee River was a favorite pastime. In the 1920s, boys learned to swim in Carter's Ice Pond which was just a wide place in the Kishwaukee River on the south side of Taylor Street. In the winter, Mr. Carter cut big chunks of ice to store and deliver to his customers in the summer time. (Courtesy of Steve Bigolin.)

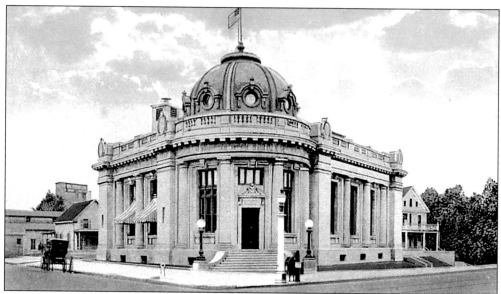

DeKalb Post Office (1906–1960) was built by the Charles W. Gindele Company of Chicago for nearly $65,000. The date of their award for this building was March 28, 1905. It was an imposing structure, the proportions and lines architecturally perfect and all together pleasing to the eye. It had the latest plumbing, with hot and cold water systems. The lighting was combination gas and electric. The furniture and fixtures were all quartered sawed white oak, antique finished. Above it all was a flagstaff with the stars and stripes "floating forever," wrote one newsman. Alas, that was not meant to be and it was demolished in 1995 for a parking lot at the Walgreen Drug Store at 100 West Lincoln Highway. (Courtesy of Steve Bigolin.)

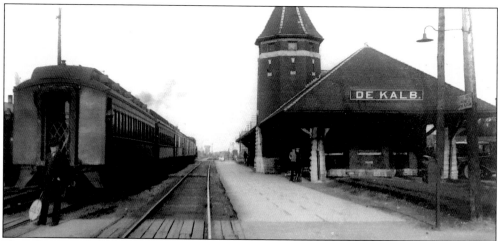

The Chicago & North Western Railroad Station, c. 1923. In 1845, the managers of the Chicago & Galena Railroad contracted to build the DeKalb to Dixon line. Terms called for a train to reach Dixon by January 1, 1854. At the time of the railroad's arrival, Buena Vista, as DeKalb was then called, had a population of 29. The Pioneer Locomotive was the 37th built by Baldwin in 1837. Its top speed was 25 miles per hour, with only hand brakes. After the railroad came to DeKalb, the population increased from 557 to 1,855 by 1891. Industry prospered with a shoe factory, farm industry manufacture, wire fence, butter, doors, gloves, and cheeses. In 1890, 175,000 tons of freight were shipped from DeKalb. (Courtesy of Steve Bigolin.)

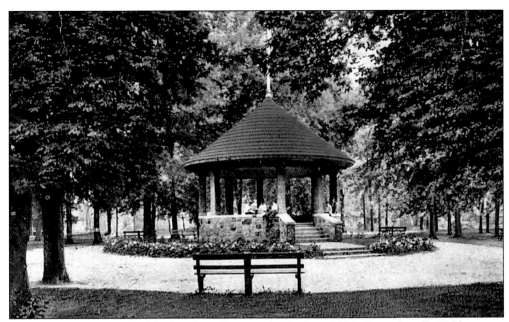

This is a penny postcard of the bandstand in Huntley Park, c. 1900s. Laura Ingalls Wilder wrote that "it is the simple things of life that make living worthwhile, the sweet fundamental things such as love and duty, work and rest, and living close to nature." We might also add the joy of listening to a summer band concert! (Courtesy of Steve Bigolin.)

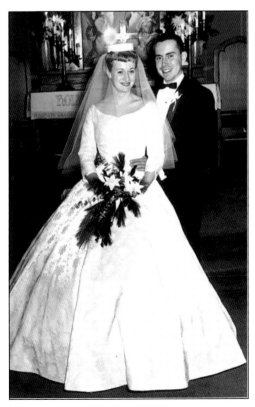

Alice and Harry Erickson were married on December 29, 1961, in West Chicago. Harry worked at AT&T as a program engineer until his retirement in 1989. Alice worked at Waubonsee Community College until her retirement in 2001. Their home in Hinckley, Illinois, DeKalb County, was built in the 1860s. They are the parents of two children. Linnea is the CEO of Visiting Nurses Association in Aurora, Illinois and Mark is employed with State Farm Insurance. They have two granddaughters, Karina and Katje, whose parents are Linnea and Larry Windell. (Courtesy of Alice Erickson.)

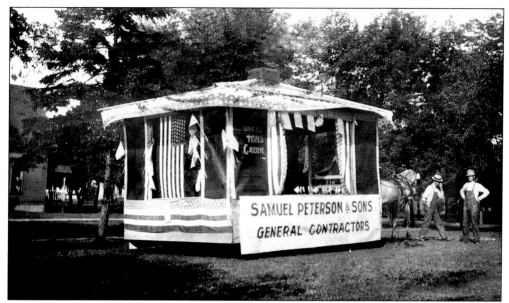

Sam Peterson was a prominent late 19th century builder in DeKalb. The purpose of this horse-drawn structure is unknown. The photo remained in the family for over 100 years. Where and when it was taken is unknown. (Courtesy of Steve Bigolin.)

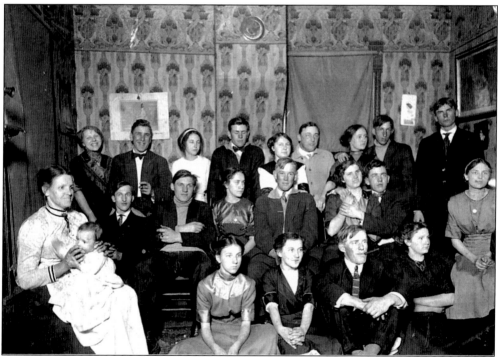

A family gathering about 1940 in celebration of Thanksgiving. It must have been a large turkey to feed this group! Trinity Lutheran Church was erected this year. Changes to DeKalb's public utilities included coal gas to water gas and then to natural gas. Some vocabulary words from that time include blitz, ersatz, walkie-talkie, and kamikaze. (Courtesy of Barbara Wallin.)

The date on this holiday postcard is December 21, 1911. Families were busy preparing for Christmas. The trees had been cut from the neighboring woods and decorated with cranberry and popcorn strings, tiny bird ornaments, pinecones, and nuts. Children were baking cookies with their moms and aunts. The horses were given extra treats of oranges and carrots. And the stillness of the season brought a radiant peace to all. (Collection of Jo Fredell Higgins.)

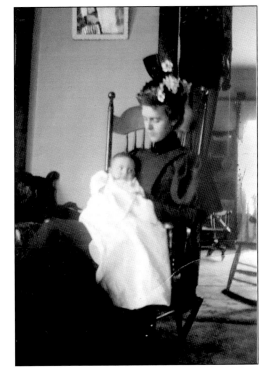

Grace and Florence, last names unknown, c. 1927. They were mother and daughter who took a moment to pose together. The song "Me and My Shadow" was popular that year and seems likely to apply to their relationship. (Courtesy of Charles Bradt.)

J.W. Glidden, his wife Mabel, and baby Nansen on Christmas Day 1897. It might be said of them that "For contemplation he, For softness she, and sweet attractive grace." (Courtesy of Jessie Glidden.)

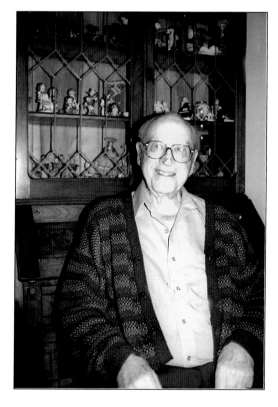

Charles Bradt turned 100 years young on November 28, 2003. The teddy bear, named for President Theodore Roosevelt, was introduced in 1903. The Boston Red Sox won the first World Series. The first western movie, *Kit Carson*, opened and had a running time of 21 minutes. The Wright Brothers achieve powered flight from the sand dunes at Kitty Hawk, North Carolina on December 17, 1903. Engineers and inventors Wilbur and Orville powered the plane with an 12-horsepower motor. Also in 1903, the Ford Motor Company was founded by Henry Ford. Charles sat for this photo in his living room during the summer of 2003. (Photograph by Jo Fredell Higgins.)

Five

EDUCATION AND NORTHERN ILLINOIS UNIVERSITY

"Listen to the song of life."

–Katherine Hepburn

America's basic tenants of public education were initiated first by the Land Ordinance of 1785, which set aside the 16th section of every congressional township for school purposes. Two years later, the Northwest Ordinance stated that "the happiness of mankind, school and the means for education shall forever be encouraged." With the Land-Grant Act of 1862, Midwestern states were empowered to found the great state university system. The backbone of education in DeKalb County for over a century was the township common school. Towns were free to establish their own school systems and they did. Wesley Park was appointed the first school commissioner of DeKalb County on November 7, 1837. He subsequently reported that he had received $170 from the state treasury and had loaned most of it with interest. In 1861, a brick building was erected at a cost of $25,000 for a grade school. The well-known name of Isaac L. Ellwood helped to build this first schoolhouse. The population of DeKalb was 1,900. The early training of teachers was generally meager until the 1860s. It appears there were no well-defined common standards for determining teacher qualifications until that time. Into the early 20th century, completion of eighth grade was thought to be adequate.

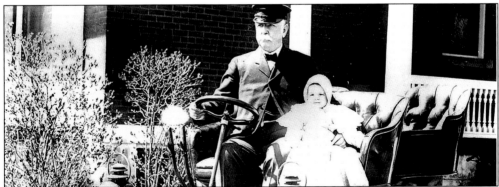

Northern Illinois State Normal School opened in DeKalb on September 1, 1899 in one unfinished building. At the suggestion of Jacob Haish, Joseph Glidden, who was called "the grand old man of DeKalb County," broke the soil with a lead pencil preparatory to building. The pencil was emblematic of literature and education. The student body consisted of 146 women and 29 men, with a faculty of 15. First President John W. Cook is shown here with his granddaughter. He held only a normal school education from Illinois State Normal School in Normal, Illinois. (Courtesy of Sally Stevens.)

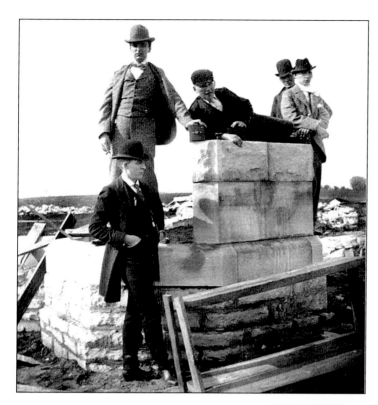

The men in bowler hats created a striking pose on top the cornerstone of Northern Illinois State College in 1899. The man on top the stone is grandfather Gilbert N. Blackman, who was DeKalb city clerk at that time. His granddaughter is Elaine Johnson Cozort. (Courtesy of Elaine Johnson Cozort.)

John G. Peters became president of Northern Illinois University on June 1, 2000. He is the 11th chief executive officer and oversees a comprehensive university with 7 colleges and about 25,000 students engaged in 120 areas of study. His distinguished academic career includes twenty years in teaching and administrative roles at the University of Nebraska–Lincoln. Dr. Peters and his wife Barbara Cole Peters have a son Russell, who lives and works in Knoxville, Tennessee. (Courtesy of NIU.)

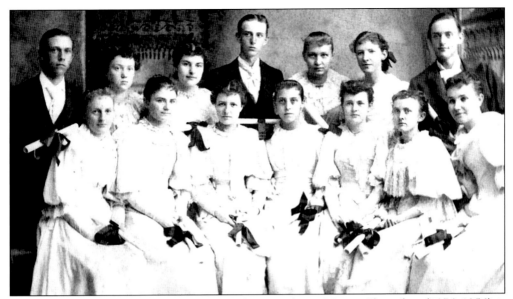

The DeKalb class of 1894 sit for their graduation photo. Hattie Cheesebro (1876–1956) is seated in the front row, second from right. The DeKalb Ladies' Literary and Social Circle was organized in 1888, and members were especially interested in the study of American and British authors and English literature. Prominent women joined and stated that they wished to exert a "genuine love of culture and knowledge." (Courtesy of Sally Stevens.)

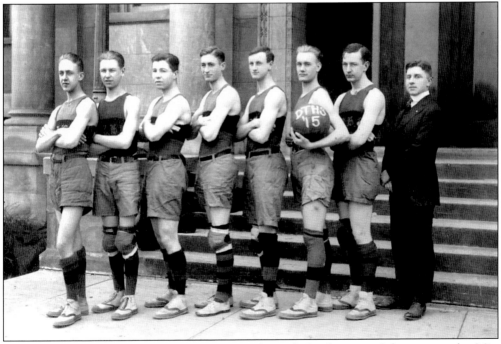

The DeKalb High School class of 1915 appear to be ready for the game. A letter to employ Miss Beulah Shonle in 1912 offered an 8-month contract at $45 per month and she was to do the janitorial work. "We want you to scrub the school house at least every two months. Pay particular attention to reading, penmanship, and spelling," the contract stated. (Courtesy of Barbara Wallin.)

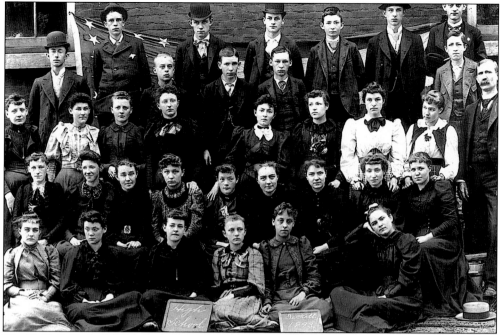

The DeKalb High School class of 1893 posed with determined looks. Hattie Cheesebro is the second from right, front row. Sanford Allen Tyler Sr. is top left, back row. The Tyler Elementary School would be constructed in 1970. In 1893, an electric light and power plant was constructed and the city was able to have the full length of Main Street lighted at night. Main Street was finally completely paved with brick. (Courtesy of Tyler Family Photos.)

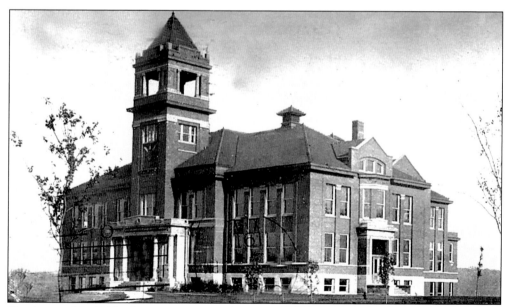

On August 10, 1911, this penny postcard was mailed from DeKalb. Shown is the DeKalb Township High School. There were over six million immigrants to the United States during this decade. Of whom many were unable to read or write in any language. DeKalb became home to some of them. (Courtesy of Steve Bigolin.)

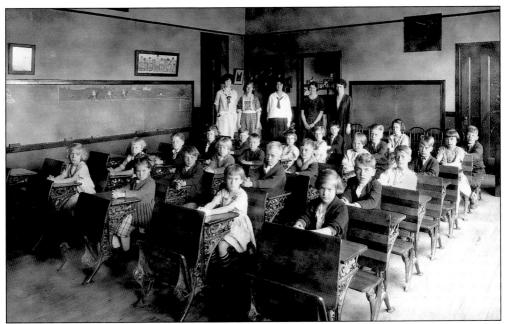

A splendid classroom of second graders with teachers Mrs. Gable and Miss Fogg in April 1923 at the Normal Training School in DeKalb. The charming little girl in the first row, second from the left, is Alice Blackman. (Courtesy of daughter Elaine Cozort.)

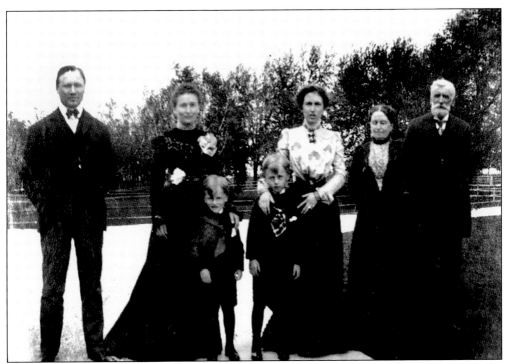

Franz Lundberg, Stella and Bruce Heures, May Ellwood, Aunt Lena and Uncle Henry Gurler are the well-dressed family in this 1936 photo. The first vitamin pills were marketed in the United States this year. (Courtesy of Sally Stevens.)

Mertie Hunt Wright in c. 1900. We see a provocative pose with her elaborate dress and plumed hat. Words that became part of our vocabulary included nickelodeon, suffragette, chauffeur, and hamburger. Hamburgers were first sold in New Haven, Connecticut in 1900. (Courtesy of Sally Stevens.)

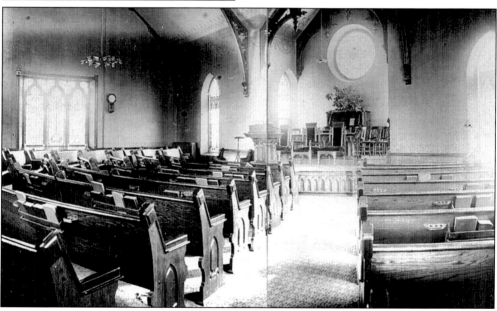

Rev. H.N. Norton organized the DeKalb Congregational Church shown here in an interior photo from 1920. That date was December 2, 1854. Worthy pioneer people in 1885 decided to build a new stone church and a contract was let to Mr. James Shannon for $2,500. On October 22, 1885, the cornerstone was laid by I.L. Ellwood. His remarks concluded with the words "and may she stand ten thousand years to the glory of God Almighty, for the good of man." (Courtesy of The First Congregational Church of DeKalb.)

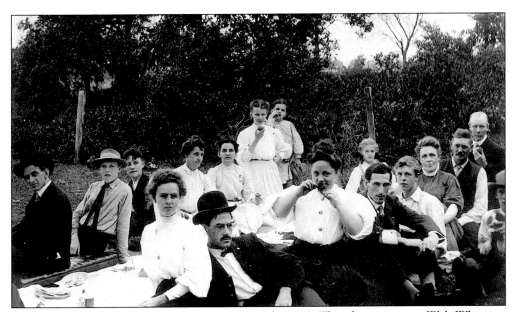

A group of friends enjoying a summer picnic in July, 1918. That day was just as Walt Whitman had written, "Give me the splendid silent sun with all his beams full-dazzling." In those days, the family and dearest friends were the center of all activities. They had just carried the flag together in a Fourth of July parade. Savory beef roast, fried chicken, macaroni salads, lemonade, and chocolate brownies were enjoyed at noontime. (Courtesy of Sally Stevens.)

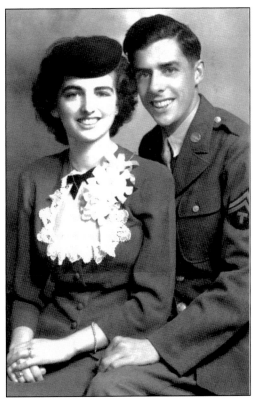

Norma Clapsaddle Smith and Charles Smith on their wedding day in 1943. Harvard developed the first computer, Mark I, the following year. In 1946, the faculty numbered 82 at Northern. Also in 1946, DeKalb's radio station started with a studio in the Wright Building on Fourth Street. There was no transmitter so they operated through WMRO in Aurora for the first six months. Pleasant family evenings were spent listening to Jack Benny, Amos and Andy, or the Kraft dramas on a Mohawk radio. (Courtesy of Sally Stevens.)

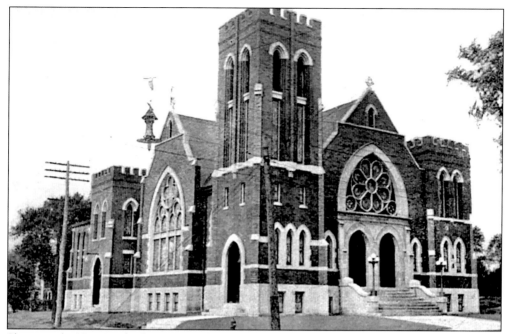

Shown is the New Methodist Episcopal Church. Jacob Jenks was a local preacher in this church in the 1840s. The first revival of religion in DeKalb County was held in his brother's barn in 1837 and was conducted by Jacob. The Jenks brothers started the first sawmill in the township and it was run by waterpower. An upright saw was used. Religious services were also held at David Walrod's house early in 1836. (Courtesy of Steve Bigolin.)

The year is 1906 and the unidentified family members gather for a photograph. The well-known New Year's Eve song "Auld Lang Syne" was released by Columbia in 1907. (Courtesy of Sally Stevens.)

It is Easter Sunday in DeKalb and these two delightful children in matching outfits hold their matching bunnies. It is 1949. Scrabble, the word game, is launched in the United States. Do you suppose their parents had the game to play after dinner that Easter? (Courtesy of Sally Stevens.)

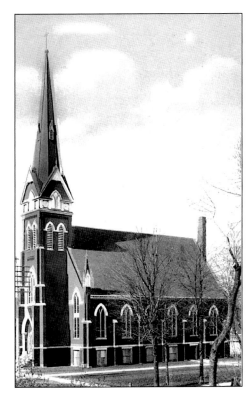

On January 17, 1914, this postcard was mailed to a friend in Chicago. This Swedish Lutheran Church was also a warehouse for DeKalb Ag before being torn down in the 1960s. (Courtesy of Steve Bigolin.)

65

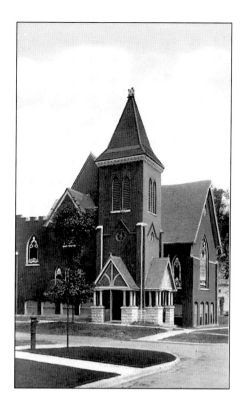

A greeting from a friend in Cortland, Illinois to DeKalb, Illinois was mailed in 1912. It shows the First Baptist Church. A pipe organ was donated to the church by Jacob Haish shortly before his death. (Courtesy of Steve Bigolin.)

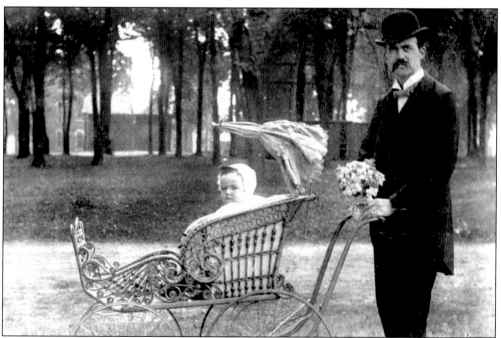

Henry Rolfe and his son Burton are taking a bouquet of flowers to Mrs. Burton on this quiet Sunday in June. The carriage is quite lovely, as is this photograph. Henry may have sung "Let Me Call Your Sweetheart" to her. It was released in 1911 by Columbia. (Courtesy of Sally Stevens.)

A Wallin family reunion was held in the summer of 1913 on South Fourth Street. Since the first home electric refrigerators were marketed this year, the picnic items could be kept cold without the need of the iceman. German potato salad, dried fruits and nuts, ham and cheeses, and many tasty desserts were eaten that day. (Courtesy of Barbara Wallin.)

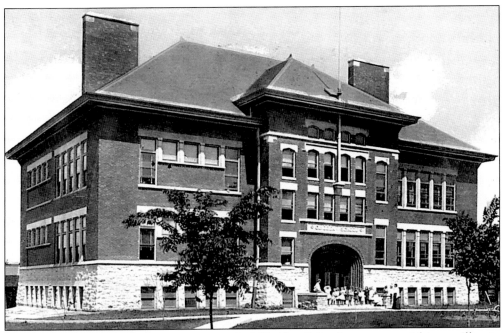

It was February 25, 1912. A penny postcard of Glidden School was sent to Chicago, Illinois. Named after Joseph Glidden, the school would be torn down in 1973–1974. In Mabel Glidden's memoirs, we read that his wife Lucinda tried to wake him one day from a nap with the question, "Isn't there something you could be doing?" And his drowsy reply was said to have been, "Not that I can see at the moment."(Courtesy of Steve Bigolin.)

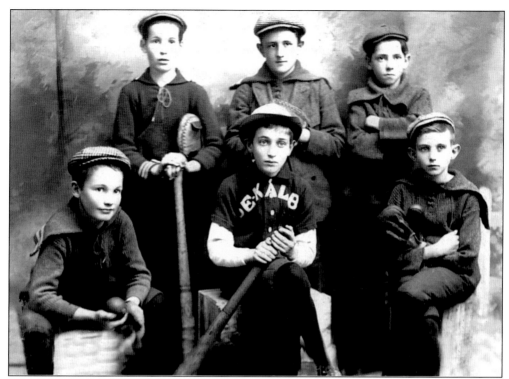

"The Dirty Seven" baseball team, c. 1900. Pictured, left to right, are (back row) Jim Ellwood Lewis, Ed Duncan, Pete Earl, (bottom row) Perry Fiske, Clay Olsen, and Reggie Fay. (Courtesy of Ellwood House Museum.)

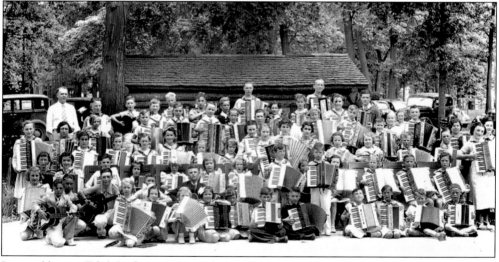

Pictured here is Eskil Anderson's Accordion Band in Hopkins Park on Sunday, June 13, 1937. The DeKalb Band began in 1854, and was organized by Jackson Hiland. It was the first of its kind west of Chicago and was called the DeKalb Silver Cornet Band. In 1903, the band accepted an invitation to become the Band of the Third Regiment of the Illinois National Guard. It took many civic-minded musicians to raise the needed money for uniforms, instruments, and music. (Courtesy of Barbara Wallin.)

This 1942 photo shows the Bushriders motorcycle group at Joe Salkawski's 25th birthday party at his home on Coltonville Road. They rode Harley-Davidson's or "HOGS" (Harley Owners Group). Harley-Davidson, an American marketing marvel, began operations on August 31, 1903. Founders William Harley and Arthur Davidson, who were 21 and 20 years old respectively, wanted to take the work out of bicycling in 1903. They tried to patent its distinctive sound, but were unsuccessful. DeKalb has a Harley-Davidson Museum with over 65 antique and modern motorcycles, vintage clothing, and other memorabilia. (Courtesy of Barbara Wallin.)

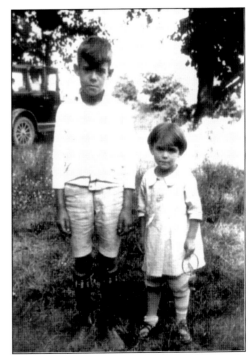

In 1926, Cousin Jack Devine and Barbara Groves enjoyed an area park. Such delightful children! William Blake, the poet, had written that, "I was walking alone in my garden and there was a great stillness among the branches and flowers and more than common sweetness in the air." (Courtesy of Barbara Groves Wallin.)

St. Mary's Catholic School and Hall in 1931. The first resident Catholic priest was Rev. John Murray, who was appointed to organize the parish and build the first church in 1861. It was a frame building on the corner of Fourth and Pine Streets. In 1899, the large Bedford stone, cathedral-like church was built. It seats more than 600 and still serves DeKalb today. St. Mary's Parochial School was established in 1913. (Courtesy of Steve Bigolin.)

Sean Michael Higgins was born on July 20, 1993. His mother is Suzanne Helen Higgins and his father is Patrick Reinhartz. This is one of my favorite photos of Sean, taken on the NIU campus on November 3, 1994. (Photograph by Jo Fredell Higgins.)

On a beautiful autumn day in 1989 Suzanne Helen Higgins smiles. After a stroll on the NIU campus, we enjoyed lunch at The Crystal Pistol Restaurant in DeKalb. The interior decoration resembled a Victorian boathouse with stripped awnings, ceiling fans, antiques, and porcelain fixtures. The meals were wonderful with tender white fish, homemade muffins, fresh salads, and desserts. Sadly, it is now closed. (Photograph by Jo Fredell Higgins.)

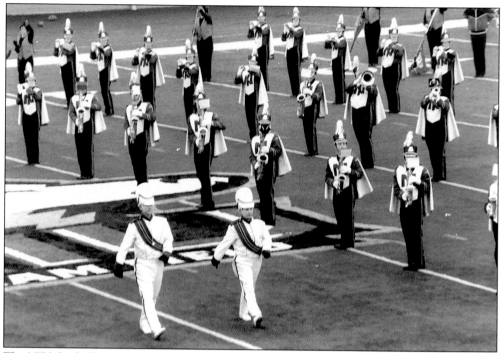

The NIU football team had a championship season 2003. This is a photograph of the band on November 22, 2003. The team beat Eastern Michigan University with a score of 38–24. Their 7-0 start caught the attention of *USA Today*, which ran a story of running back Michael Turner. *Sports Illustrated* profiled the Huskies in their October 13th edition. (Courtesy of Mark Starkovich.)

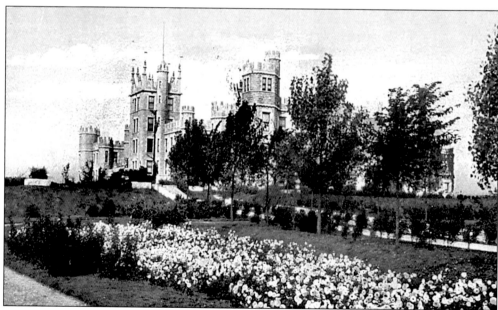

On July 5, 1909, this postcard was mailed from DeKalb. It depicts Altgeld Hall at Northern Illinois State Normal School in DeKalb. (Courtesy of Steve Bigolin.)

Six

THE SANDWICH FAIR
AND OTHER DELIGHTS

"All, everything I understand, I understand only because I love."

–Leo Tolstoy

Once upon a time, the year was 1858. On the east side of Sandwich, Illinois, a one-day October fair exhibited two tables of corn for farmers to compare. In 1860, the first fair in the present location was named the Sandwich Agricultural Institute. Later, some members started the first Sandwich Fair and 10 men bought 20 shares of fair stock for $2,000. By 1889, the gate receipts showed a $278.92 profit. By 1923, electricity kept the fair open at night. Autos were 25¢ days and free at night. Adult admission was 50¢. The 1944 fair recorded attendance at 21,000 and men and women in uniform were admitted free. Entertainment included summer follies,

vaudeville, and the circus. By 1970, the fair recognized couples who had been married 50 years and admitted them free. They were given lunch tickets and a free photograph beside an antique surrey or automobile. The *Sandwich Free Press* encouraged, "Bring a picnic and eat lunch or supper on picnic tables under the trees."

The Sandwich Fair, also known as the DeKalb County Fair, celebrated its 116th annual fair from September 3–7, 2003. It is the oldest continuous fair in the state. The visual pleasures of perfect melons, roses, or cabbage in the Horticulture Building, the desserts and hand-sewn items in the Home Arts Building, the photography and jewelry in the Arts and Crafts Building, or the toys, pens, and glassware in the Antiques and Collectibles Building are beautiful to behold. (Courtesy of the Sandwich Fair Association–Joan Hardekopt.)

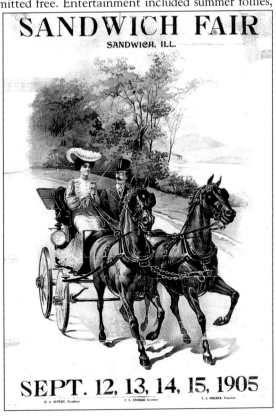

SANDWICH FAIR

SANDWICH, ILL.

SEPT. 12, 13, 14, 15, 1905

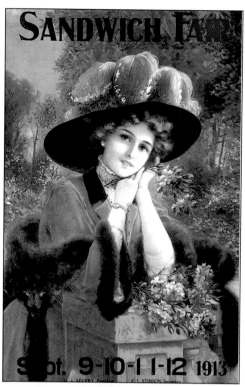

The felt fedoras and derbies that were worn to the fair at the turn of the century have been replaced by a more casual dress. In 1913, however, women wore elaborate hats to church, social gatherings, and to the Sandwich Fair. (Courtesy of the Sandwich Fair Association–Joan Hardekopt.)

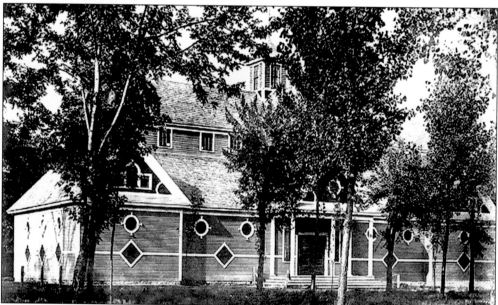

Amid the oak groves, Industrial Hall was built in 1905. It housed the home arts, women's handcrafts, and industrial arts. Sky shows were popular at the fair. Since 1889, balloon ascensions had been a major attraction. In 1900, the official United States population was 76,295,220 in forty-five states. Eastman Kodak sold a new Brownie box camera for one dollar. The average worker earned $12.98 per week after 59 hours of labor. (Courtesy of the Sandwich Fair Association–Joan Hardekopt.)

The Egyptian Theatre is listed on the National Registry of Historic Places. Built as a palace of romantic enchantment as a "verdant garden of old Egypt…the exotic lure of a moonlit night on the Nile," the theater opened on December 10, 1929, at a cost of $300,000. The 1,600 seats were filled despite a winter storm. Two inaugural programs featured a movie on opening night. *The Hottentots*, starring Edward Horton and Patsy Ruth Miller, was billed as the "talking screen's fastest, funniest, romantic farce." Admission was 50¢ for adults and 25¢ for children. Live vaudeville acts, organ concerts, and stage productions have been held here. John F. Kennedy spoke at the theater during his presidential campaign in 1960. (Courtesy of Dan Grych.)

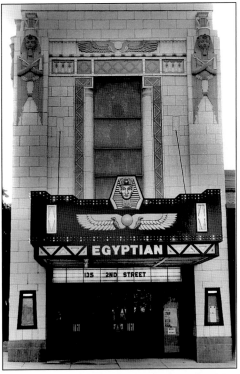

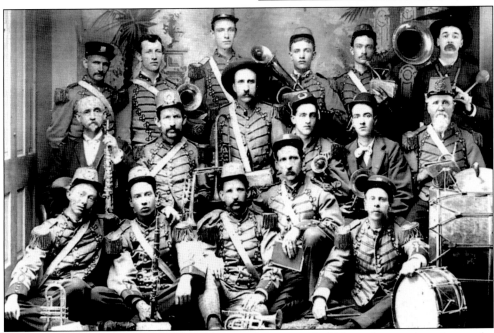

The DeKalb Municipal Band, *c.* 1885. In 1892, it consisted of 20 regular members. It was the first band to play in Denver, Colorado about 1858. Silver Coronet Bands were popular in the 1870s, as well as military bands. In 1876, Jacob Haish built an Opera House that served for many years as a center for artistic endeavors. Dee Palmer has been the director of the DeKalb Municipal Band for the past 55 seasons. (Courtesy of Steve Bigolin.)

The Cracker Jax is an eclectic shopping experience in DeKalb. Lauren Woods began her shop 18 years ago. Vintage postcards and stationery, incense and perfume bottles, antique jewelry, clothing and hats, books, and glassware all pose quietly in this unique shoppe. It is a pleasure to open the door and enjoy all the visual and sensual delights. (Courtesy of Dan Grych.)

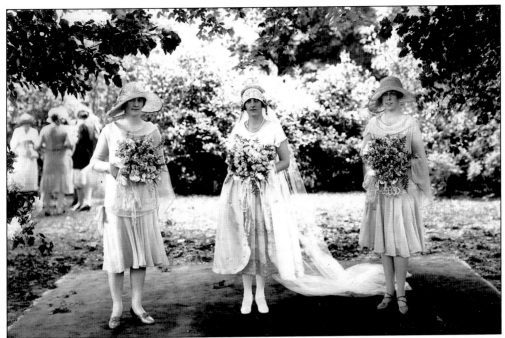

A lovelier wedding photo would be difficult to imagine! One can almost hear the birdsong and the leaves rustling as these beautifully dressed women pose. The bride and attendants pictured are, from left to right, Eleanor Parson, Elizabeth Bradt, and Mary Ann Bradt. The year was 1920. (Courtesy of Charles Bradt.)

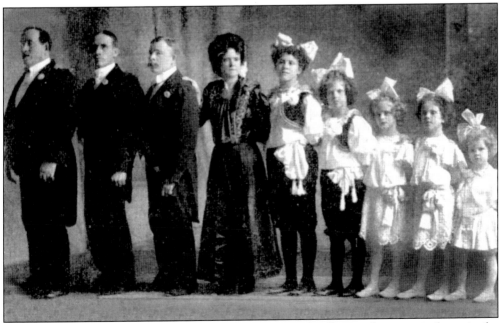

Pictured is the Nelson Family, who toured with their vaudeville act of gymnastic shows in the 1920s. They dressed well when performing, as we can discern from this photograph! (Courtesy of Charles Bradt.)

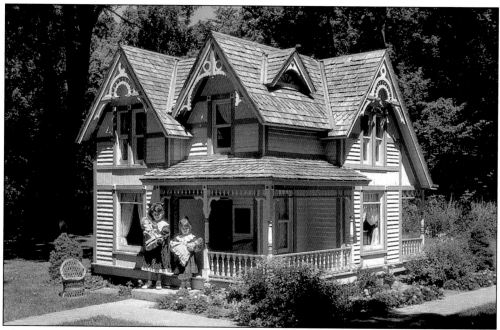

The "Little House" was built in 1891 and was enjoyed as a Victorian playhouse for the grandchildren of Isaac Ellwood. It was originally used as a contractor's model and parade float. It was returned to Ellwood Park in 1973 by Mrs. Burt Oderkirk, and restored to its original appearance at the Ellwood House at 509 North First in DeKalb. (Courtesy of Ellwood House Museum)

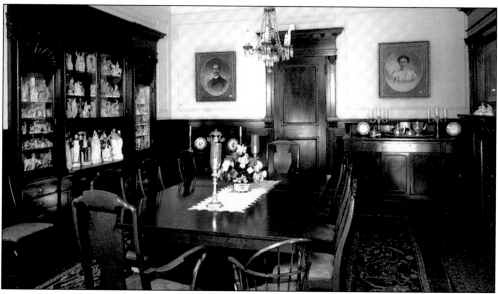

Shown here is the magnificent mahogany paneled dining room that was re-modeled in the Georgian style in 1898. The 22-room home was built by barbed-wire baron Isaac Ellwood in 1879. Originally a 1,200-acre estate, it extended from First Street to the Kishwaukee River, and from Lincoln Highway to Rich Road. Ellwood was born in Salt Springville, New York in 1833. He married a farmer's daughter, Harriet Augusta Miller, and they raised seven children. (Courtesy of Ellwood House Museum.)

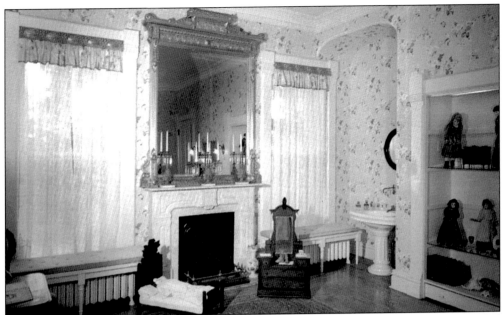

Perry and May Gurler Ellwood, the second generation to occupy the Ellwood House, traveled extensively to England, France, and the Orient. They were involved in the war efforts of both world wars. After Perry's death in 1943, May Gurler closed the top two stories of Ellwood House during an energy conservation program. Shown here is the blue bedroom (1910–1930). (Courtesy of Ellwood House Museum.)

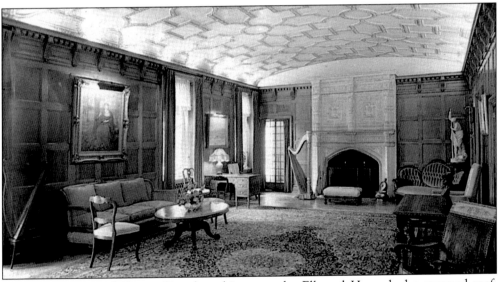

Exemplifying Second Empire French architecture, the Ellwood House had a mansard roof, porte-cochere, sweeping porch, and bay windows. It cost $50,000 to build in 1879 because workmen earned 10¢ an hour and worked 10 hours daily. Former Governor John Tanner gave the title of "Colonel" to Isaac Ellwood. Many other famous people were friends of the Ellwood family including Jane Addams, founder of Hull House, and President Theodore Roosevelt. The mansion contains ornate furnishings of the period and collections of both historic and artistic interest. (Courtesy of Ellwood House Museum.)

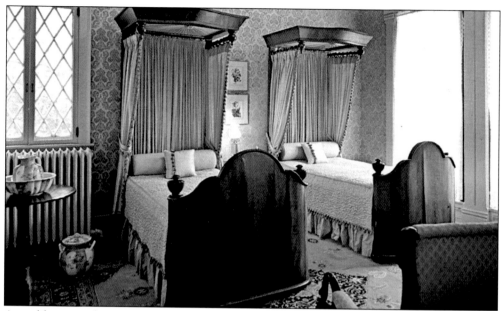

A prickly piece of wire invented 130 years ago gave DeKalb its mark in history as the birthplace of barbed wire. In 1873, Jacob Haish, Isaac Ellwood, and Joseph Glidden saw a need for fencing that was "horse high, bull strong, and pig tight." Each man began to twist sharp wire points around smooth wire and each was soon manufacturing the barbed wire. The homes that the wire fortunes built reveal the personalities of Glidden, a farmer, and Ellwood, a hardware merchant. They are designated National Historic Places. The home of Haish, lumber dealer and carpenter, was demolished in 1961. Shown here is a bedroom in the Ellwood House. (Courtesy of the Ellwood House Museum)

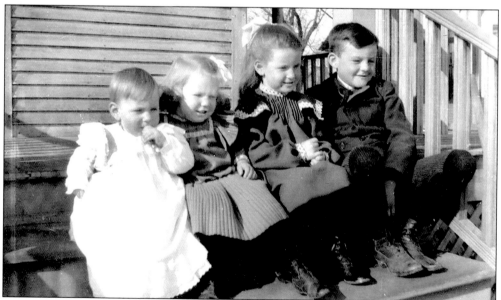

Four unidentified children on a porch in DeKalb about 1940. The previous year had a hit song, "Over The Rainbow," that was released on the Decca label. Did the soft rain shower that September day produce a rainbow? (Courtesy of Sally Stevens.)

Henry Rolfe, head cashier at the First National Bank in DeKalb, pauses for a moment following a huge snowstorm on February 7, 1936. In 1859, E.T. Hunt and John Hamilton formed a banking company located at 236 East Lincoln Highway. After changes in ownership, the DeKalb National Bank was formed in 1882. H.P. Taylor was president, Jacob Haish was vice president, and T.A. Luncy was cashier. In 1902, it became the First National Bank of DeKalb. (Courtesy of Sally Stevens.)

Christmas Eve, 1998, and the world is hushed, still, expectant. All is quiet, the "tumultuous quiet of storm" when children dream dreams and St. Nicholas is on his way. Who among us does not become childlike during this splendid season? Cheerful hearts and pleasant visits with family and friends can ameliorate the dreary wintertime for awhile. (Courtesy of Dan Grych.)

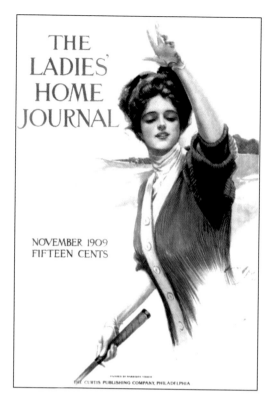

THE LADIES' HOME JOURNAL

NOVEMBER 1909
FIFTEEN CENTS

THE CURTIS PUBLISHING COMPANY, PHILADELPHIA

In November 1909 it was chic to play tennis, dressed appropriately of course! When the game was finished, it was time for tea. Since the General Electric Company produced the first electric toaster this year, the tea sandwiches could be warmly toasted, covered with chicken salad or ham and served with strawberries and angel food cake. (Collection of Jo Fredell Higgins.)

Mabel Carter Glidden was born in 1871 and died in 1967. She was 96. This photo of Jessie Glidden's mama was taken in 1930. Mabel was born in DeKalb and attended the Art Institute in Chicago. She wed John in 1896 and gave birth to five children. Nansen, Doris, Carter, Jerrold, and Jessie were their children. She started the Glidden flower shop in a small greenhouse at their home. Mabel was a charter member of the Library Whist Club (Courtesy of Jessie Glidden.)

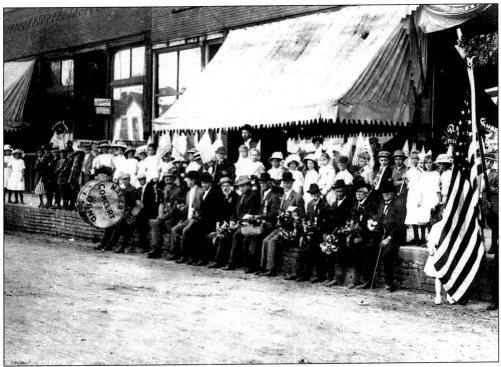

It was Memorial Day 1908. The parade was coming through Malta, Illinois as these well-dressed residents waited in eager anticipation. (Courtesy of Ivan Prall.)

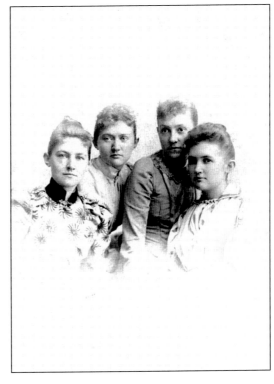

A Cabinet Portrait shows the four Carter sisters in the 1890s. Pictured, left to right, are Jessie, Eva, Cleo, and Mabel. (Courtesy of Jessie Glidden.)

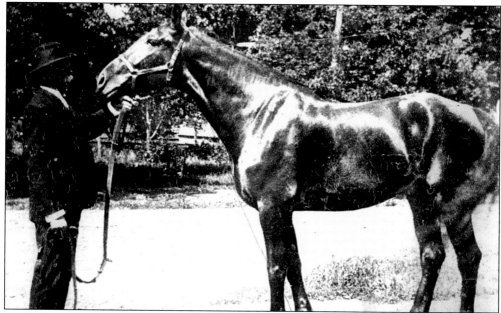

Sanford A. Tyler Sr. and his horse "Crum" stop for a while in the 1880s. Sanford had traveled by wagon to Virginia City, Montana in 1864 to mine for gold. He then returned to DeKalb and engaged in the grocery business. In 1883, he became superintendent of the Ellwood wire works. He retired from active business life in 1897. Until his death on November 14, 1906, he remained a man of sterling character and most lovable nature. (Courtesy of Tyler Family Photos.)

DeKalb Hospital Auxiliary president Mrs. Sanford A. Tyler Jr. and her children, Christine and Timothy, enjoy a moment before dinner in September 1957. In 1915, a group of 20 doctors' wives formed the DeKalb Public Hospital Benefit Club. They met monthly for a social afternoon of sewing. They rolled bandages during World War II in addition to sewing, hemming sheets and pillowcases, making dresser scarves, and canning for the population of 10,000 in 1930. On March 12, 1954, another group formed the Women's Auxiliary of the DeKalb Public Hospital. (Courtesy of Tyler Family Photos.)

Seven

CLUBS AND ORGANIZATIONS

"The Mother with the ever open doors, the feet of many Nations on her floors, and room for all the World about her knees."

–Lord Tennyson

Each immigrant brought his customs and traditions to the shores of America. A writer in 1893 pondered the question of what had the United States done to receive such a glorious gathering of Frenchmen, Scottish women, Swedes, Germans, Poles, Finns, and Spaniards. Tremendous energy and definite enthusiasm, ambition to excel, unlimited territory to explore and conquer brought, and not empty-handed, dazzling, ingenious, and worthy men and women. Names recorded here include Russell Huntley, who laid claim to a large track of land and during his first year broke 300 acres and made four miles of rail fence. He was an enterprising man. Jacob Haish and G.D. Hueber were from Germany, Andrew Bradt from Brandische, Germany, William Plank from Holland, Charles H. Salisbury and John G. Davy from England, John MacQueen from Scotland, and James Coyne and Samuel Peterson from Sweden. They joined others who immigrated from Vermont, Pennsylvania, Michigan, and New York to establish a lumberyard, set up a medical practice, farm in the rich DeKalb soil. All were representatives of a hard-working citizenry. Their sterling qualities of honesty and integrity awakened respect and confidence. Thus, DeKalb prospered in every regard.

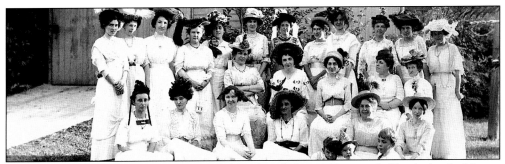

The Library Whist Club, which Annie Glidden founded in 1899, provided books for the library. Annie is shown here, seated second from the right in the front row. The club's second pursuit was to study the game of whist, which was the forerunner of bridge. Funds raised at balls, fairs, and concerts filled the library shelves. The 21 charter members read each book to be certain that it reflected the correct moral tone. The dues were $2 a year. In 1908, the *Daily Chronicle* reported that a Whist Club luncheon was "a most delicious lunch served in a dainty manner." The women dressed in fancy dresses, elaborate hats, and gloves for their Monday afternoon meetings. (Courtesy of Tyler Family Photos.)

In 1983, the DeKalb Area Garden Club was organized. Membership brings together men and women who share the fellowship of gardening through programs and projects. This cherub ponders the garden of Don Mack. (Courtesy of Don Mack.)

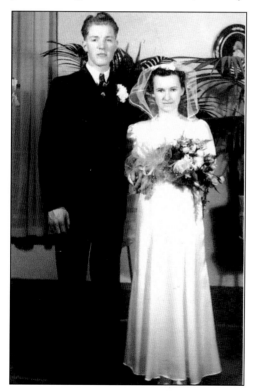

Curtis and Alice Johnson on their wedding day, January 29, 1938. They wed in the 1856 family home at 210 North First Street, which great-grandfather Eli B. Gilbert had built. Alice was born on February 28, 1915. Curtis was born in September 1915 and died on February 25, 2002. He was an accountant and vice-president of finance for the Turner Corporation in Sycamore, Illinois. Turner produced propane equipment and they did the Olympic torch for the Lake Placid, New York games in 1980. Curtis and Alice had two children, Elaine and Richard, and three grandchildren. "I live in the house as a fifth and sixth generation family. We have the original boiler but heating has gone from coal to oil to gas," said 89-year-old Alice on a recent visit. (Courtesy of Elaine Johnson Cozort.)

On April 29, 1840, the DeKalb County Board of Commissioners noted that 10 percent of the proceeds of the sale of lots was to be reserved for the county library pursuant to law. The city council passed an ordinance on July 1, 1893, that established a public library located at city hall. In 1923, the library moved to the second floor of the *Daily Chronicle*. At first, the library carried only newspapers, magazines, and donated books. In the early 1900s the library boasted a typewriter that took a 75¢ ribbon. With a bequest of $150,000 from barbed wire millionaire Jacob Haish, the Haish Memorial Library Building was dedicated on February 15, 1931. (Courtesy of Dan Grych.)

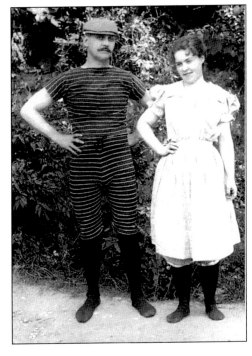

Where did these two go to swim that hot July afternoon in 1926? In the summertime, children went swimming in the Kishwaukee River. Sycamore had a municipal pool and the "quarry" pool in Rochelle provided some variety. Some drove to Dixon to the Lowell Park swimming pool where Ronald "Dutch" Reagan was a lifeguard. DeKalb did not have a municipal pool until the 1920s. (Courtesy of Joiner History Room-Phyllis Kelley.)

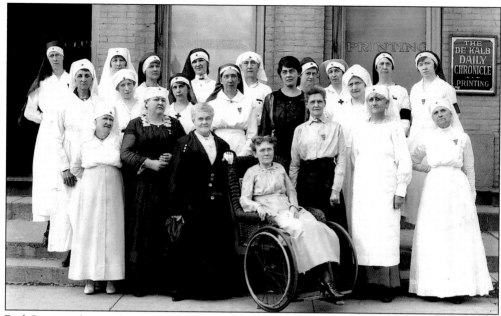

Red Cross workers gather in this 1930s photo. It was also in 1930 that nurse and student pilot Ellen Church began work as a stewardess for Boeing Air Transport, a predecessor of United Airlines. Early flight attendants had to be single, under the age of 25, shorter than 5 feet 4 inches and lighter than 115 pounds. (Courtesy of Sally Stevens.)

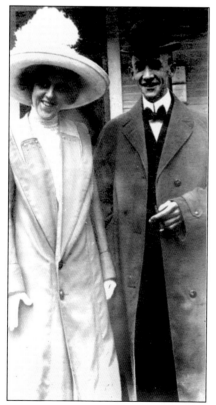

Earle and Mary Smith on their wedding day, June 20, 1912. One interesting tradition in DeKalb County was the "belling" of couples. The couple was serenaded with kettles, horns, and pot lids. The couple was awakened by these clanging bells and beating kettles. They are then taken by truck to the downtown area. A wheelbarrow was provided and the groom was expected to wheel the bride down the main street. Afterwards, the newlyweds treated their friends to ice cream and cake. Some neighborhoods had old school bells or church bells that were put on the back of the truck and rung continuously during the "belling." (Courtesy of Sally Stevens.)

Marian Marcella Weaver Johnson is held by her mom, Geneva Keller Weaver, about 1909. A beautiful photograph indeed! (Courtesy of Wynne Lou Johnson Swedberg.)

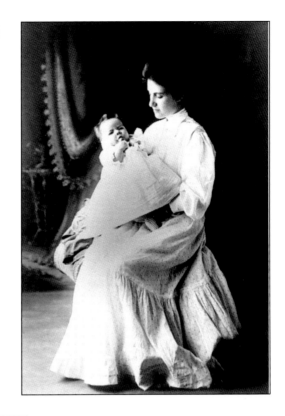

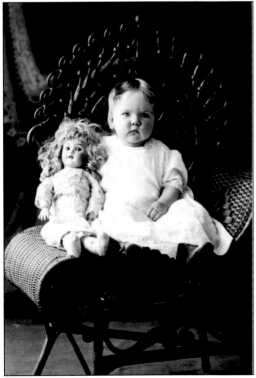

Marian Marcella Weaver Johnson with her Schoenhut doll in 1911. She later married Ray Johnson on August 23, 1932, in St. Louis. They co-owned the Rainbow Café in Princeville, Illinois. They had two daughters, Wynne Lou and Raylene June Johnson Hodges. They later hired my father, Ray Fredell, as a chef in their restaurant! (Courtesy of daughter Wynne Lou Johnson Swedberg.)

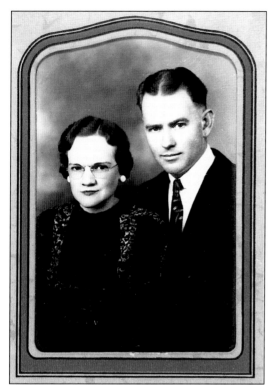

The year was 1934 and Marian and Ray Johnson pose for the camera. Marian could not let it be known that she had wed or she would lose her teaching job. So she continued to live at her parent's home for one year rather than lose her job. Her father, Mayor Earl Weaver of Princeville, Illinois, and his wife invited friends to their home in December 1933 to announce their daughter's marriage. (Courtesy of daughter Wynne Lou Johnson Swedberg.)

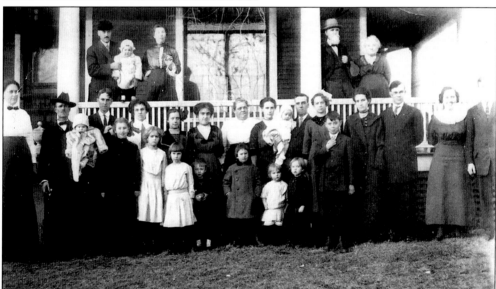

The Keller and Dart families about 1912. Emanuel Keller, pictured at top right, had marched with Sherman to the sea. His other four brothers were also in the Union Army. He is Wynne's great grandfather, pictured standing with her great grandmother Marian. Just in front of them are her grandparents, Earle Roscoe Weaver and Geneva June Keller Weaver, who were newlyweds. Their wedding date was June 10, 1908. Earl Roscoe Weaver held the US Patent No. 2,210,825 for a mechanical pencil. He filed for the patent on March 25, 1940. (Courtesy of Wynne Lou Johnson Swedberg.)

Mother Marian Weaver Johnson (standing)
holds sister Earline Theobald. Winnie and
Vernon complete this family gathering, *c.*
1910. (Courtesy Wynne Lou
Johnson Swedberg.)

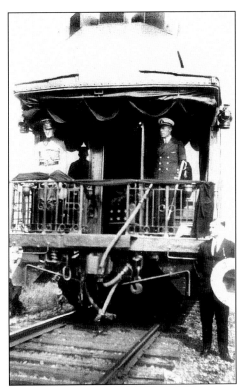

In 1923, the funeral train of President William
Howard Taft came through DeKalb County.
The train stopped for water and coal on its
passage west. The casket can be seen in this
photograph. (Courtesy of Ivan Prall.)

Surviving Civil War veterans were watching the Taft funeral train as it passed through Malta, Illinois, six miles west of DeKalb. (Courtesy of Ivan Prall.)

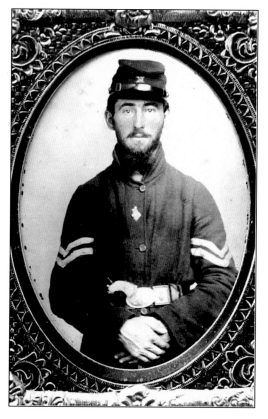

Lyman H. Needham was born on August 15, 1838, in Vermont. He was appointed Sergeant with Co. K 42nd Illinois Volunteers in January 1863. He was wounded and taken prisoner on September 20, 1863, at Chickamauga, Georgia. On September 1, 1864, he died at Andersonville, Georgia. He was 26 years old. Lyman was the great-great uncle of Elaine Johnson Cozort of DeKalb. (Photograph by O. Ryerly of Parkersburg, Iowa, courtesy of Elaine Johnson Cozort.)

Willber Blair, son of Jessie and James Blair, smiles in this 1915 photo. (Courtesy of Ethel Taylor.)

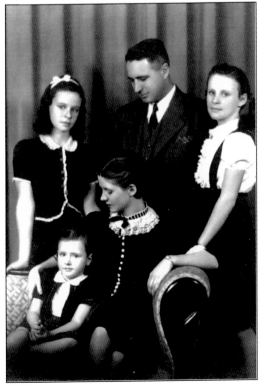

Charlie and his wife, Jane Bradt, pose with their three children in the 1940s. The children are Barbara, Bertha, and Betty Bradt. (Courtesy of Charles Bradt.)

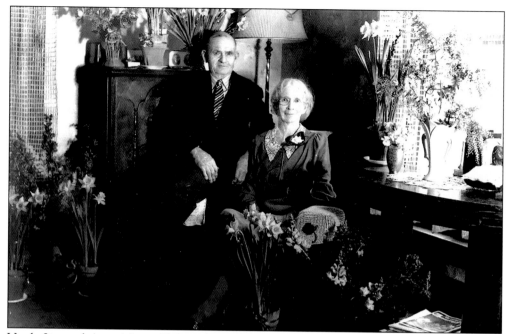

Uncle Jim and Aunt Mertie Hobenicht in February 1944. It is the occasion of their Golden Wedding Anniversary. (Courtesy of Charles Bradt.)

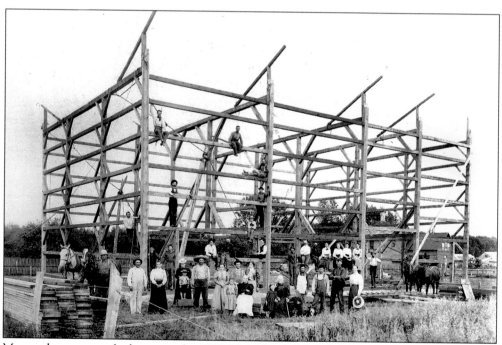

Men and women worked to erect the 1873 Malta High School. (Courtesy of Ivan Prall.)

Lieutenant Allen C. Newby is busy at the Sandwich Fair in 2003. The DeKalb County Sheriff's department ensures that the county roads are secure and peaceful. The sheriff is the chief law enforcement officer in the county. As an elected official, he is accountable to the citizens he represents. (Photograph by Jo Fredell Higgins.)

Hazel Carr in this 1920s photograph is going to the movies! My, how they dressed during this decade! Whether the destination was a community activity such as a play or a dance, the women wore hats and gloves. Their feminine natures regarded proper dressing for special occasions as a necessity. (Courtesy of Ethel Taylor.)

Jim Blair, Gladys Davenport, and several friends smile in this 1935 photo. Had they just visited the new DeKalb Public Library, a gift of Jacob Haish? In July 1935 the *DeKalb Daily Independent* was taken over by the *Chronicle*. (Courtesy of Ethel Taylor.)

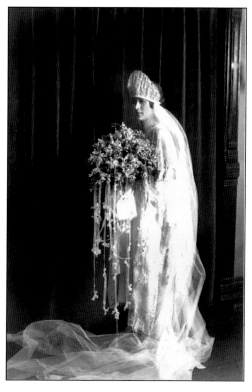

Mary Ann Bradt in her wedding photo of 1922. A splendid view of a spectacular dress and flowers! (Courtesy of Charles Bradt.)

Elizabeth Jane Bradt resembles a china doll in this pose. It must have been a very cold winter's day! Braving the DeKalb cold became an act of beauty. (Courtesy of Charles Bradt.)

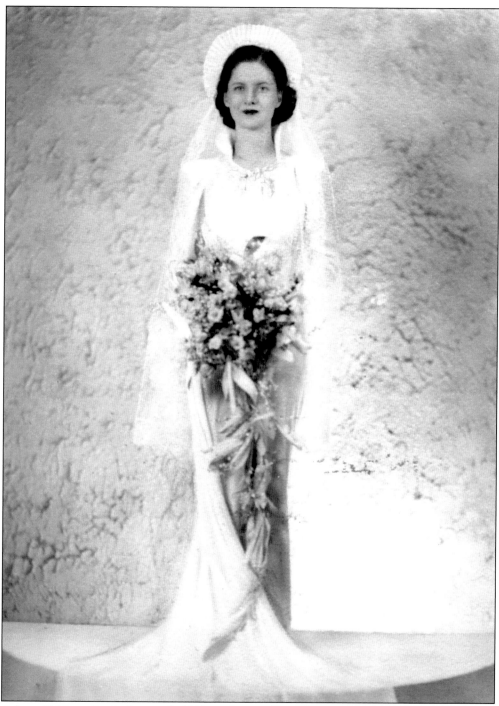

A beautiful Jane Bradt, January 1, 1939, on her wedding day to Charles Bradt. Ancestors had arrived in America from Fredrikstad, Norway on August 26, 1636, according to Bradt family documents. Charles Willard Bradt was born on November 28, 1903. He wed Irene Townsand on August 19, 1926, and they had three daughters. Irene died in June 1935. Shown here is Elizabeth Jane Zinn Bradt on her wedding day to Charles. (Courtesy of Charles Bradt.)

Eight

LIVING WELL IN BARB CITY

"A rising nation, spread over a wide fruitful land advancing rapidly to destinies beyond the reach of the mortal eye."

–Thomas Jefferson

Three august men of DeKalb are credited with the invention of barbed wire. They thereby significantly changed the landscape of America. Joseph Farwell Glidden was born on January 18, 1813, in Charlestown, New Hampshire. In 1842, his family traveled west and settled in DeKalb County. Joseph regarded farming as the most noble profession for him. He purchased 600 acres in the township and at the time of his death on October 9, 1906, owned 1,600 acres. The scarcity of Illinois timber made lumber fencing quite expensive, so through investigation and experiments he applied for a patent of his barb wire on October 27, 1873. Joseph was issued his patent 13 months later, No. 157,124, for his barbed wire called "The Winner." The barbs were cut by hand and parts of an old coffee mill were extemporized as a machine for coiling them about the wire. Isaac Ellwood received a patent for his barbed wire on February 24, 1874. Within five months, however, he realized the superiority of Glidden's design and paid Glidden $265 for a half interest in his yet to be issued patent. This invention made them very wealthy men. Ellwood had a net worth of $400,000 by 1900. Ellwood was making $1,200 a day from the

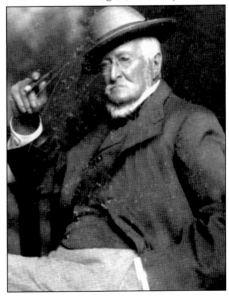

manufacture of barbed wire! Ellwood left an estate valued at $30 million. Jacob Haish also applied for a patent and built his first barbed wire factory in DeKalb in 1874. On June 25, 1874, Haish ran interference papers against Glidden's patent. They spent the ensuing 18 years in federal court until, finally, Glidden's patent was upheld.

Joseph Farwell Glidden purchased a riding horse and came through the tall prairie grass to DeKalb on November 14, 1842. The following spring, he purchased 400 acres of land located on section 22 in DeKalb Township, a mile west of the village. He paid $1.25 per acre to his cousin Huntley. His place became a model farm property. Joseph became a center "around which social and political organization was accomplished. He was a natural leader, a friend, and patron for every betterment of his fellow men." (Courtesy of Charles Bradt.)

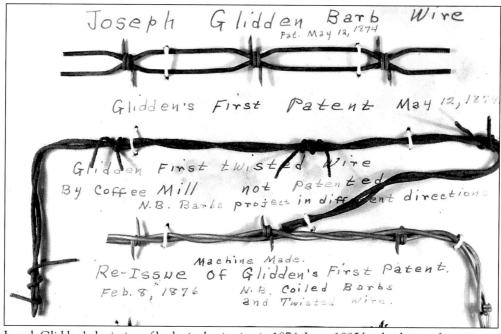

Joseph Glidden's depiction of barbwire beginning in 1874. In an 1885 book edition of prominent citizens of DeKalb County we read, "He is essentially a member of the class descended from the 'grand old gardener,' and he has remained true to his lineage, which is closely akin to dignity itself. Glidden takes justifiable pride in the well-earned title of a farmer of DeKalb County, pure and simple." A cousin to Russell Huntley, Glidden and his wife Clarissa had moved into a newly-built cabin in June 1843. In the spring of 1884, Clarissa Foster Glidden died giving birth to their baby daughter. A few months later the baby, Clarissa, also died. (Courtesy of Yvonne Johnson.)

This Internal Revenue License was issued to Andrew Bradt on August 1, 1866 for the sum of $7. Andrew and Charles Bradt had opened a glove factory in 1865. In 1865, the population of DeKalb was 1,282. In 1870, the firm would become Bradt and Shipman Glove Company. (Courtesy of Charles Bradt.)

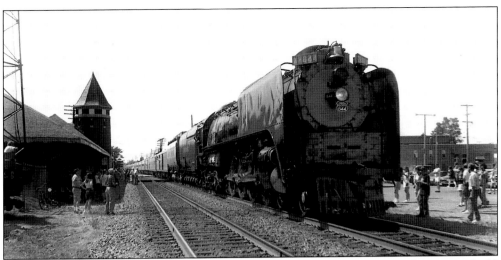

Briefly, in its beginnings in 1837, DeKalb County was created as a near perfect rectangle 18 miles from east to west and 36 miles north to south. In 1848, the northern half of DeKalb County produced 115,000 bushels of wheat, above what was locally consumed and used for seed. The Chicago & North Western Railroad came to the county in 1853. At its peak in 1905, there were three steam railroads for handling the products and passengers in the DeKalb area. Prosperity came with the railroad and the county began to depend upon it for economic health. After the corporation known as the Galena & Chicago Union Railroad began coming through DeKalb County, Russell Huntley sold some of his land along the right of way in the area called Huntley's Grove, about five miles southwest of Sycamore, along the south branch of the Kishwaukee River. (Courtesy of Dan Grych.)

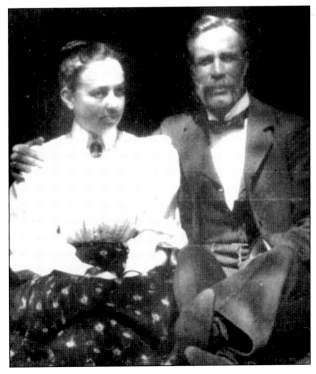

Dr. Edward L. Mayo and his wife, Harriet Ellwood Mayo (daughter of Isaac Ellwood), sit on their front porch steps in 1898. Dr. Mayo may have thought of his dear wife as "a beautiful woman, beautifully elegant, impresses us as art does, changes the weather of our spirit." Their home was located at 105 North First Street. This Richardsonian Romanesque residence was built the previous year. Dr. Mayo died in 1905. In 1922, Harriet sold her home to the Elks Club and moved to California. The Elks occupied it from 1922–1994. (Courtesy of Jim and Catherine Hovis.)

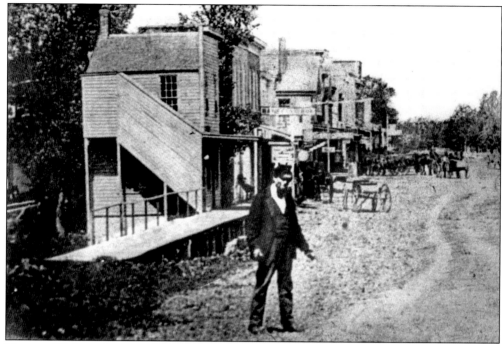

Norman Wadsworth, an early carpenter, stands looking east toward Fourth and Main Street (East Lincoln Highway) in one of the earliest photographs of DeKalb. It is charming in its simplicity. (Courtesy of Jim and Catherine Hovis.)

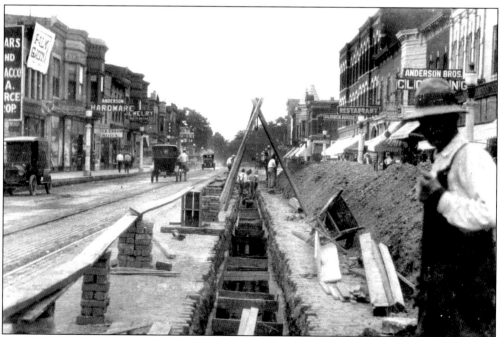

Steam pipes are lowered onto Main Street to furnish heat for the stores and restaurants, c. 1910. This view of downtown DeKalb is looking west on Lincoln Highway from Third Street. The power plant provided the excess heat. (Courtesy of Jim and Catherine Hovis.)

The Jake Crawford Cigar Factory on Main Street in 1896. Cigar making was then a local trade. At that time there were 27,000 cigar factories in the United States. An average workman made 150 hand-wrapped cigars in a day. Most sold for 5¢ or less. (Courtesy of Jim and Catherine Hovis.)

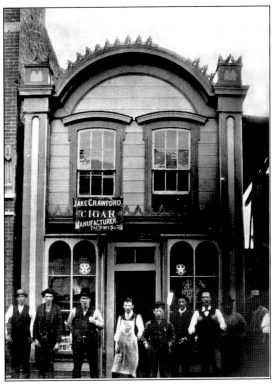

Ott Shaver is seated in his 1906 hack, facing South on First Street. He is stopped in front of the 1905 copper-domed post office building. This hack cost $2,100 and was advertised for weddings, funerals, and special events. (Courtesy of Jim and Catherine Hovis.)

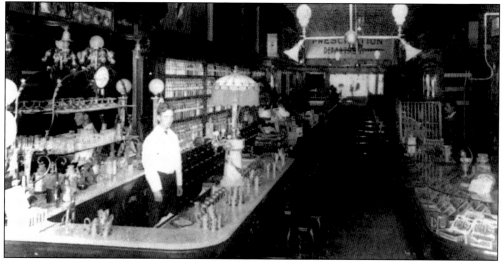

Shown is the interior of Kirchner's Drug Store in the Haish Opera block at the northwest corner of Third and Lincoln Highway. A lemonade or cherry coke with almond cookies could be enjoyed at the soda fountain. Prescriptions could be picked up at the back of the store. Women's face cream, cigars, aspirin, or baby lotions could also be purchased. (Courtesy of Jim and Catherine Hovis.)

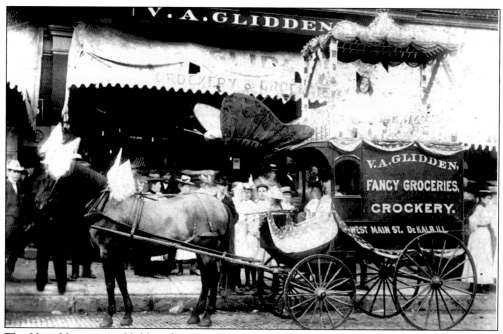

The Hon. Varnum A. Glidden, fancy groceries and crockery, was located in the Glidden House Block at the northeast corner of Second and Main Streets in DeKalb. On August 1, 1875, he had arrived in DeKalb and on March 7, 1887, purchased the grocery business of Roberts & Tyler. He was supervisor of DeKalb in 1890 and president of the county board. In 1905, he was elected mayor. He wed Miss Emma Noble in 1869 and they had two children. After her death in 1875, he married Miss Mary Foster. She died in 1882 and he married Miss Susie E. Stewart in 1884. They had eight children together. Mayor Glidden contributed to DeKalb's advancement and progress by all his commendable community service. (Courtesy of Jim and Catherine Hovis.)

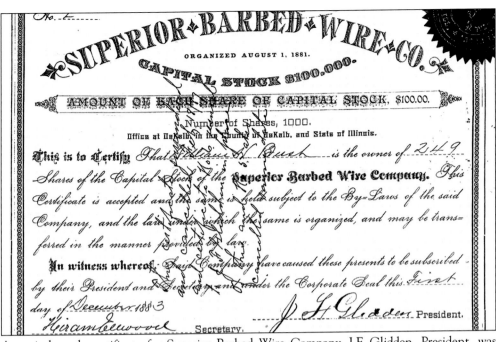

A capital stock certificate for Superior Barbed Wire Company, J.F. Glidden, President, was issued in December, 1883, for 249 shares. Glidden was known as a man of faultless honor and of faithful friendship. He was one of Illinois' most prominent and worthy citizens. He was a staunch Democrat and was elected county sheriff in 1852. When his successful and accomplished efforts ended in grateful rest and quiet at age 93, the life of this man would be remembered with genuine regard, affection and good will. (Courtesy of Jim and Catherine Hovis.)

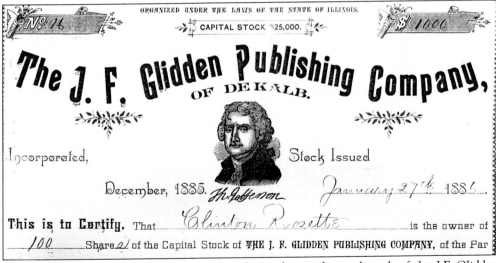

In December 1885 Clinton Rosette purchased 100 shares of capital stock of the J.F. Glidden Publishing Company for $10. What could describe the inventive genius of this unusual man? NIU President John Cook remarked, "There are mysteries of heredity and rare endowment before which science stands mute. There was always a charming originality and freshness about him [Glidden] that made his conversation as stimulating as wine. There was an original unexpectedness that gave his thoughts a peculiarly interesting flavor." (Courtesy of Jim and Catherine Hovis.)

Shown is an interior view of the Sherman Printing Company, located in the Haish Building in DeKalb. (Courtesy of Jim and Catherine Hovis.)

A tavern in Malta, c. 1915. Malta, DeKalb County, is six miles west of the city. Its population was then about 1,000. Malta had 13 taverns! Billy van Artsdale is shown with an apron and moustache in front of his "Sample Room" tavern. (Courtesy of Ivan Prall.)

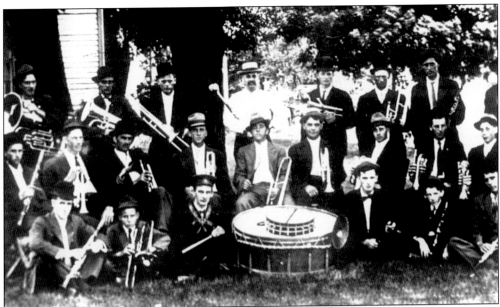

Shown is the Malta Concert Band, *c.* 1900. Were they preparing a patriotic program for the Memorial Day Parade that year? Did their evening meal consist of pork, red cabbage, and corn? Immigrant families usually had three cooking utensils, which consisted of an iron tea kettle, a three-legged skillet with an iron lid, and an iron pot, which hung from a crane in the fireplace. They were cleaned with vinegar and salt, rinsed well, and rubbed with grease. (Courtesy of Ivan Prall.)

The Jacob Haish home in DeKalb around 1923. Jacob was born in Brandische, Germany on March 9, 1826. He came to America at age nine. In the spring of 1847, he married Miss Sophia A. Brown. Their home was "most beautiful, surrounded by every comfort and convenience that wealth can secure and refined taste suggest." Jacob died on February 19, 1926, and left his fortune to various charities. (Courtesy of Yvonne Johnson.)

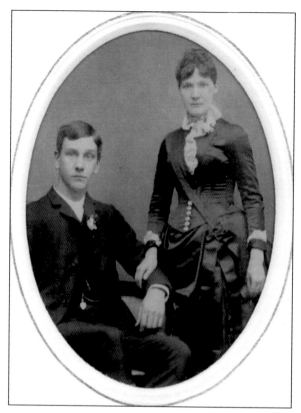

Andrew Nelson and Ida Gustafson Nelson were married in 1886 in DeKalb. They had four daughters. Andrew and his dad ran a blacksmith shop on the 400 block of East Lincoln Highway. (Courtesy of Yvonne Johnson.)

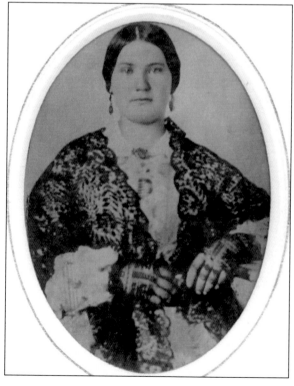

Shown is Maria Anderson Johnson who wed John Johnson in 1861. They were blessed with nine children. President Lincoln proclaimed the first official Thanksgiving in 1863 as a day of thanks and prayer. One can speculate that this family had many blessings on that occasion. (Courtesy of Yvonne Johnson.)

Photograph shows Haish's new Electric Power and Gas Engine plant November 1, 1908. The smokestack was struck by lightning on Saturday, July 28, 1906. (Courtesy of Yvonne Johnson.)

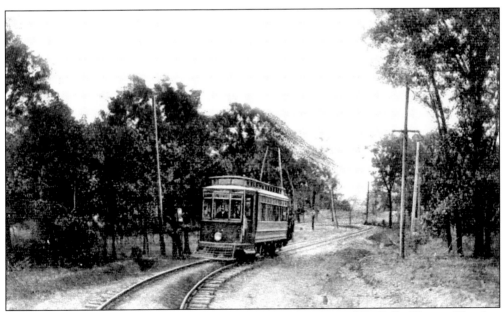

Shown is the interurban trolley that ran between Sycamore and DeKalb, Illinois. The fare was 5¢. A Woodstock and Sycamore Traction Company gasoline car was nicknamed the "Woodpecker Special." It ran from Sycamore to Woodstock through Genoa and Marengo. This postcard was dated September 13, 1906. (Courtesy of Yvonne Johnson.)

A pen of prize winning white Plymouth Rock chickens, bred and owned by Walter Smith, in DeKalb. The fence is a Union Lock Poultry Fence that was made by the Union Fence Company in DeKalb. In 1884, the United States government had granted more than 250 patents for various fencing designs. There were at least 13 different manufacturers in the DeKalb area in 1884. By 1900, over 400 US patents were issued. Overall, 1,600 variations of barbed wire had been catalogued, although most were short-lived and experimental. (Courtesy of Yvonne Johnson.)

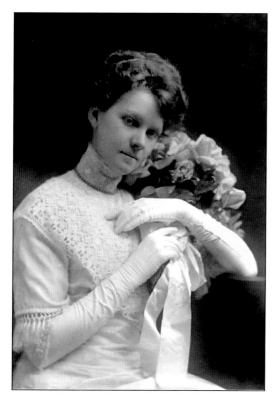

Virginia Nelson Johnson was born in DeKalb in 1889. She wed Albert O. Johnson on March 6, 1912. This is her exquisite wedding portrait. They were married 52 years before his death. Their three children were Elaine, Kenneth, and Yvonne. Yvonne graduated from NIU in 1951. Yvonne taught at a rural school for two years and then taught at West School, in Sycamore, for 48 years. Currently, she is in the Media Center at West School. She earned her master's degree from NIU, plus additional course work at Penn State, Rutgers, Aurora University, ISU (in Normal, Illinois) and Rockford College. (Courtesy of Yvonne Johnson.)

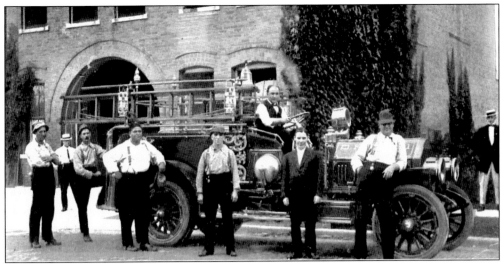

The DeKalb Fire Department, c. 1914. Established in 1869, with a hook and ladder company, it was manned by volunteer firefighters. The equipment was made by Phineas W. Vaughan, a blacksmith. He used wheels from old wagons to make a crude truck for holding the wooden buckets, three upright ladders, and one roof ladder. The first hose company was organized in 1874. William H. Miller was named captain of the Hook and Ladder Company when it formed in 1880. In 1887, a box alarm system was installed at a cost of $195.28. The department remained volunteer and paid per call until February 3, 1904, when it became the first full-time, paid fire department. Pay was $50 a month for the first six months, then $55 per month. Men received one week's vacation with pay each year. The 1904 population was about 6,500, with the Normal School enrolling 218. (Courtesy of Yvonne Johnson.)

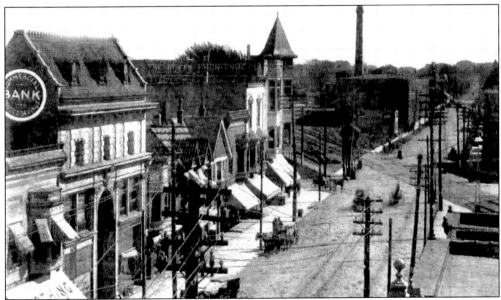

Main Street in DeKalb is shown on this November 17, 1905, postcard. The sidewalks were made of wooden boards at that time. A small stream went under the sidewalks with a crawl space there. Homes used fragrant greens and abandoned bird nests, pumpkins, and pinecones to accentuate that autumn season. (Courtesy of Yvonne Johnson.)

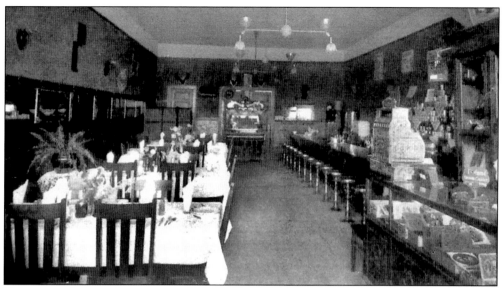

This postcard shows the interior of S.E. Williamson's White Front Café on East Main Street in DeKalb, c. 1900s. Did a tantalizing menu of meat loaf, cheddar cheese potatoes, and apple pie bring them many customers that week? For 85¢, a dinner consisting of shrimp cocktail appetizer, steak, baked potato and vegetable, pie, and coffee could be ordered at another local restaurant at the west end of Lincoln Highway. (Courtesy of Yvonne Johnson.)

One of the most well-known DeKalb faces is international model and actress Cindy Crawford who grew up in DeKalb. This photograph was taken in June 1987 when her grandparents, Dorothy and Jim Walker, celebrated their 50th wedding anniversary at the Winged Steer Restaurant. With her is Kenneth Johnson, who was born on October 17, 1916, and worked at DeKalb Ag as a hatchery manager until his retirement in 1971. He then owned the El Matador Restaurant in Sycamore for 20 years. He died on August 8, 1994. Kenneth proudly kept Cindy's picture with him wherever he traveled, according to his sister Yvonne Johnson. (Courtesy of Yvonne Johnson.)

Nine

PLEASANT DREAMS, FOREVERMORE

"The true work of art is but a shadow of the divine perfection."

–Michelangelo

This nostalgic portrait of DeKalb has shown a slower harmonious life when neighbor knew neighbor, when dad either worked the family farm or arrived home from the shop, bank, or factory in time for the family dinner hour. It was a halcyon era of quilting bees, church socials, threshing, harvesting, carriage, and pony rides. Earthly sojourns were a time of balancing family, church, work, and personal interests. The simple joys of home mattered. Helping Aunt Helen stretch the curtains over the tenterhooks, dripping wet with starch, is sweetly remembered. Putting up applesauce or raspberry jelly, baking cinnamon bread from scratch or Christmas springerli cookies in the warmth of the kitchen had such a sensual appeal. DeKalb's beginnings were established in a slower time. Long before the electronic age distanced people, time was shared with loved ones and the family dinner hour was sacrosanct. Entertainments in the 1800s included the Fourth of July celebrations in Hopkins Park, complete with hot air balloon ascensions, fireworks, and a dance at Allen's Hall. Mr. Post, editor of the *DeKalb County News*, noted in 1871 that he hoped to see "Farmers, their wives, sons and daughters, all here…come in and enjoy the day with us." From the 1860s there were debate clubs, literary societies, and the DeKalb County Agricultural and Mechanical Society Fairs. Fair prizes were given for the best plan for "farm houses, closets, cisterns," for the best treatise on the culture of fruit and ornamental trees on prairie soil, "four dollars was given to the best girl equestrian rider and two dollars was paid to the owner of the best and greatest variety of pears."

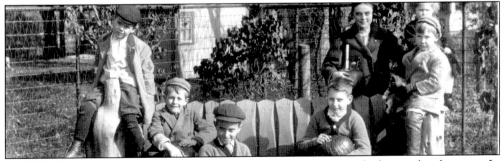

A group of neighborhood children gather on October 31, 1918, with their jack-o-lanterns. In the neighborhood was Ruth Threlkeld's garage and it offered a secure meeting place in the rafters where "the boys could have long talks on rainy days." There were other spooky barns where the girls could explore with a sense of "serene security and trusted friendships." (Courtesy of Jim and Catherine Hovis.)

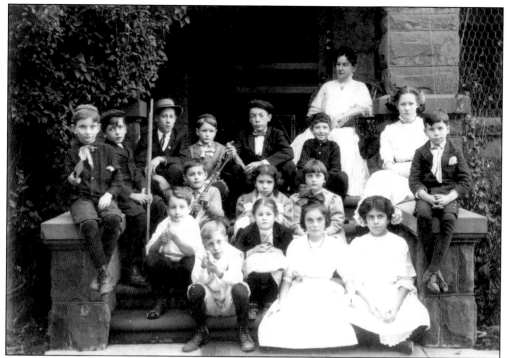

Mrs. Harriet Ellwood Mayo taught music to children in her home at 105 North First Street. Their sweet renditions of popular songs would resonate throughout the home. Girls in starched white dresses with pink satin sashes are seated next to the boys in caps and brown derby hats. (Courtesy of Jim and Catherine Hovis.)

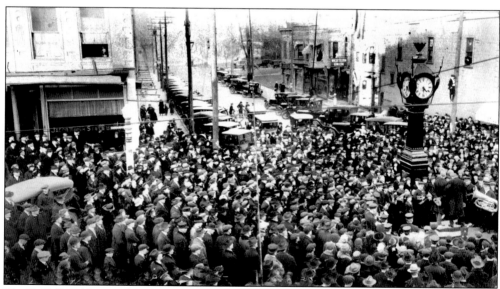

The DeKalb Soldiers and Sailors Memorial Clock was dedicated on February 13, 1924, as a World War I memorial. This scene was at Third Street and Lincoln Highway. The Jacob Haish State Bank can be seen at the northwest corner of this photo. (Courtesy of Jim and Catherine Hovis.)

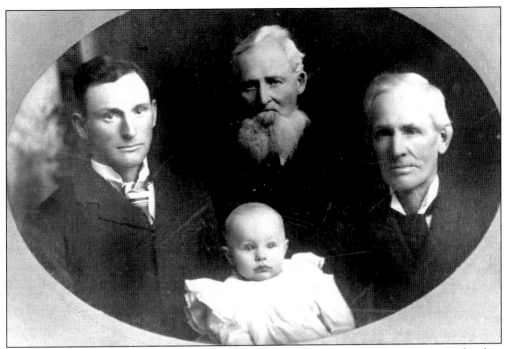

Four generations of the Hunt family make a striking pose. C. Hunt (center) was the first president of the DeKalb Council before the city began electing a mayor. (Courtesy of Jim and Catherine Hovis.)

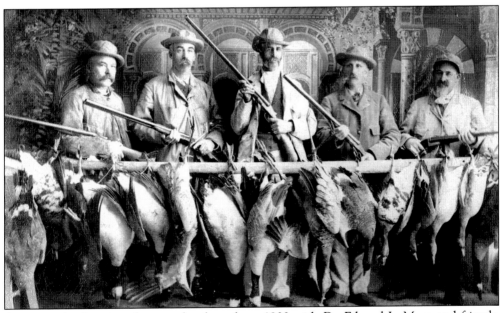

A spectacular hunting photograph taken about 1900 with Dr. Edward L. Mayo and friends. One can only imagine how many hours it took the hunters to bag them all! At the turn of the century, the skies in DeKalb were often darkened with game birds. They could have completed this hunt in just one day. Nothing was wasted and all was used for the table and the larder. (Courtesy of Jim and Catherine Hovis.)

"At the Chicago Land Show, I saw a John Deere Engine plow and believe me it was some plow. It would eat up 40 acres of ground in a day. John Deere makes 1,000 different kinds of plows. I saw a little walking plow that only cut a 6-inch furrow and an Engine plow that would cut a strip 19 feet wide," wrote E.P.S. on this penny postcard. (Courtesy of Jim and Catherine Hovis.)

In March 1898, these children were playing a game of marbles. Long ago, marbles were played with nuts or pebbles, or actual marbles as we know them today. The game "Ring Taw" began when a circle was made with string or drawn with chalk. The marbles placed inside the circle were called "nibs." The goal was to knock other marbles out of the circle and each player got to keep the marbles that she or he knocked out. The winner was the player with the most marbles. (Courtesy of Jim and Catherine Hovis.)

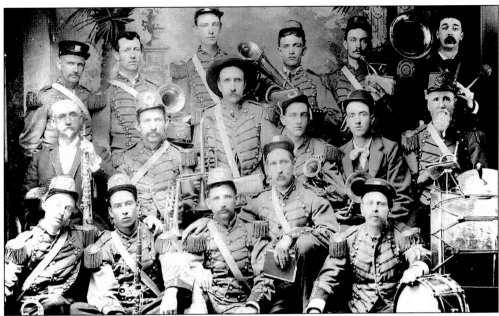

A picture of the DeKalb Municipal Band that celebrated 150 years in 2004. Music was present from the time when early settlers sang hymns together, until pianos were a common household article in the 1890s. According to Mary Ellen Pourchot, local opera houses brought a variety of traveling musicians to DeKalb. At NIU, "before the close of the first year, there were four musical organizations, both men's and women's glee clubs, a band and an orchestra." Madrigal singers and opera workshops, a university chorus, a concert choir, three steel bands, and four other groups have featured Gamelan, Chinese, African, and Tabla music at NIU. Outstanding among the university's musical offerings is the Vermeer Quartet. It has achieved international recognition. (Courtesy of Sally Stevens.)

Margaret Jane Tyler, Louise Tyler, and Patience Ellwood are shown in the 1920s enjoying a summer's day. This photograph brings a smile to my face, as I can imagine the three girls as they frolic in the warm water. Did they pick raspberries earlier in the day to make homemade jams and pies? Were summer's early roses picked to bring fragrance to a quiet corner of the living room? (Courtesy of Tyler Family Photos.)

Pictured is Margaret Jane Tyler, *c*. 1930s. She taught at the Bank Street School in New York in the 1940s. Benny Goodman, the "King of Swing," jazzed up the decorum of Carnegie Hall in New York with his classy clarinet for the first time in 1938. On April 30, 1939, Franklin D. Roosevelt opened the New York World's Fair with 60 nations on display and Albert Einstein hitting the switch to light up the expo. (Courtesy of Tyler Family Photos.)

John Ellwood, in 1920, caught in a charming pose. Was he going to the concert at Huntley Park? In 1854, eight men formed the Silver Cornet Band that later would become the DeKalb Municipal Band. They had met at a blacksmith shop on Main Street to practice. Since there were no radios or record players, the community concerts were social, as well as musical events. In the early 1900s John Phillip Sousa marches were the most popular tunes. Horses and buggies would be parked around the block at Huntley Park. (Courtesy of Tyler Family Photos.)

Grandson Isaac Leonard Ellwood II is shown in a classic pose for the wealthy. Isaac Leonard Ellwood was born on August 3, 1833, in Springville, New York. He made his first money selling sauerkraut to the boatmen on the Erie Canal. He was a salesman until he was 18 years old, at which time he left for the California gold rush. He lived there for four years before opening a hardware store in DeKalb in 1855. In 1859, he married Harriet Augusta Miller. They had four sons and three daughters. In 1879, he built a luxurious home on land that once was a part of the old Indian trail from Shabbona to the Kishwaukee River. The entire vicinity of Ellwood's stock farm included 3,400 acres of land. Isaac died on September 11, 1910, following a stroke. (Courtesy of Tyler Family Photos.)

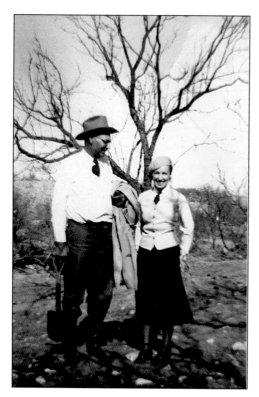

Pictured here is Patience Ellwood with the foreman of their ranch in Texas, c. 1932. Friends and family called Patty "the little general" because she was short and she usually got her way. In the 1960s, as her family began to move away from DeKalb, she was instrumental in turning over the homestead to the DeKalb Park District. She would become active in a variety of patriotic, historical, and genealogical organizations. Patty served on the executive committee board of the National Society Daughters of the American Revolution and would serve as curator general of the DAR Museum in Washington, D.C. Patience Allen Ellwood Towle was born on August 29, 1911, in Highland Park, Illinois, and died peacefully on January 25, 2004, at her home in St. Louis. (Courtesy of Tyler Family Photos.)

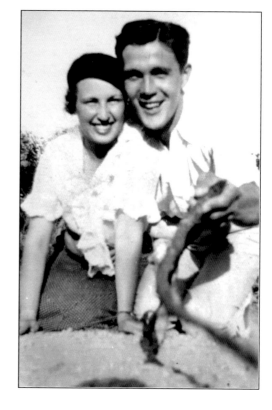

A captivating photograph of Patience Ellwood Towle and her husband Joe Towle, c. 1930s. Patience had married Dr. Joseph Towle in the garden of the Ellwood home in 1934. Towle was a professor of business at Washington University Olin School of Business in St. Louis. Patty and Joe were married for 55 years. They had two children, Selenia Rolfe and Joseph Ellwood Towle, three grandsons and three great grandchildren. Dr. Joseph died in 1988. (Courtesy of Tyler Family Photos.)

Sanford A. Tyler, born on August 9, 1918, is shown on the porch at Ellwood House in 1919. The radiance of the late summer's sun leaves shadows amid the light as it dances across the porch. Bud would become a pharmacist and then chief administrator of the DeKalb Clinic, retiring in 1986. (Courtesy of Helene Reed Tyler.)

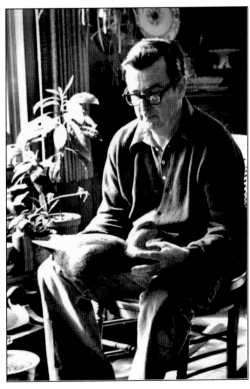

Sanford A. Tyler has been carving decoys of various shapes and species from equally varied materials for the past 50 years. He has produced over 100 miniatures of shorebirds, canvasback, mallards, black ducks, teal, and wood ducks from mediums such as balsa, cork, cedar, or pinewood. He is an avid hunter, as was his father. While hunting in the Senachwine Lake area, he uses his own decoys. The feather patterns of his puddle ducks show great detail. (Courtesy of Tyler Family Photos.)

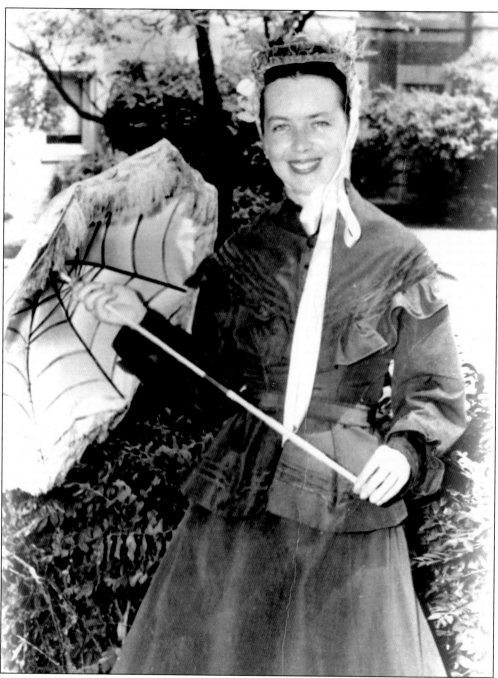

On June 13, 1956, Helene Reed Tyler wore Sarah Tyler's wedding dress and dress bonnet for the 100th anniversary celebrations of the city of DeKalb. Sarah was married in November 1869. Bud Tyler and Helene were married on August 16, 1942, and had two children, Christine T. Turk and Timothy Tyler. Helene graduated from NIU, class of 1941. She was an English and journalism major. Helene was born on February 2, 1919. She has had many civic involvements, including serving on the Ellwood House board and chairwoman of the DeKalb Hospital Women's gift shop. (Courtesy of Tyler Family Photos.)

Pete Taylor is shown in 1924 in DeKalb. He always dreamed of being a pilot and in 1946 opened an airfield on leased farmland. He provided airplane rides, flight instructions for potential pilots, and later transported patients to the Mayo Clinic. In 1947, he moved his airport to a second location and expanded to provide charter flights. He also began a first for DeKalb—crop dusting. After his death in 1983, the DeKalb Municipal Airport was renamed the DeKalb Taylor Airport in his honor. He was also posthumously inducted into the Illinois Aviation Hall of Fame. (Courtesy of Ethel Horton Taylor.)

Willard "Pete" Taylor and Ethel Horton were married in December 1950. The two lived and grew up mere blocks away from each other. They were formally introduced in 1942 when Ethel was working at DelMonte and Pete, as always, had his head in the clouds. In 1957, Ethel entered the Powder Puff Derby for the All Women's Trans Continental Air Race. Although she did not win the contest, it was a thrilling experience. "I really liked flying the Apache because it was a fast plane," she said. Over the years, Ethel has logged over 3,000 flight hours on her own. (Courtesy of Ethel Horton Taylor.)

A Memorial Service was held in DeKalb for President William McKinley, who was assassinated by anarchist Leon Czolgosz at the Pan-American Exposition in Buffalo, New York, on September 6, 1901. Isaac L. Ellwood presided. NIU President Dr. John W. Cook gave the address, "McKinley as a Public Man." The congregation sang "America." The orchestra and chorus selections included "Nearer my God to Thee" and "Sacred Dust of Noble Dead." Presidents who visited DeKalb included McKinley in 1896, Theodore Roosevelt in 1900, Warren Harding in 1923, and John F. Kennedy in 1960. (Courtesy of Tyler Family Photos.)

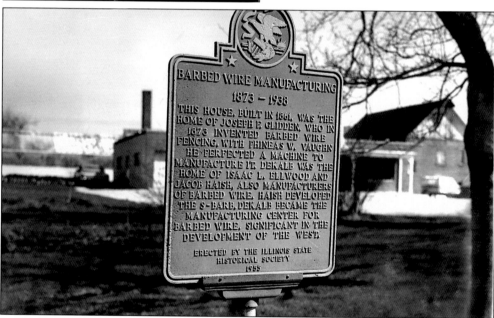

In the 1872–1873 recollections of Lucinda Glidden, she wondered where her large wire hairpins were disappearing from a milk glass dish on her dresser. At dinner one evening, Joseph reached in his shirt pocket and took out two of her missing large hairpins. He explained he was working on an idea for a fence. Together with Phineas Vaughn, the blacksmith, he took apart an old coffee mill and reassembled it, utilizing the principle of a moving sleeve and a lug. With a turn of the crank, the machine produced a small, uniform-sized coil. Soon, by twisting it with another smooth wire on a single strand, he invented the first practical barbed wire. This marker notes the home of Joseph Glidden built in 1861. (Courtesy of Jessie Glidden.)

This photograph captures the blooming magnolias at the home of Tom Sims and Pam Collins, at 407 South Second Street in DeKalb. (Courtesy of Dan Grych.)

Jessie Glidden, with forget-me-not blue eyes, was born on January 3, 1912, to Mabel Carter and John Glidden. After graduation from NIU in 1936, she worked for the Works Products Administration. In 1941, she and her brother, Carter Ames Glidden, opened up The Glidden Florist business that they sold in 1975. Wenke Hansen and her husband, Sven, purchased the shop. Carter died at the age of 96 on January 15, 1998. Jessie was a founding member and first board president of the Family Service Agency, which she calls her "first love." She was also President of the Altrusa Club and a member of the Thursday Arts Club. Jessie is shown here during the Christmas holidays in 2003. On any Sunday morning, as poet Wallace Stevens wrote, we might see her with the "complacencies of the peignoir and late coffee and oranges in a sunny chair." (Photograph by Jo Fredell Higgins.)

BIBLIOGRAPHY

"Airport Was 'Taylor' Made." *DeKalb County Weekly*. July 18, 2001.

Alleman, Annie. "Postcards From the Past," *Beacon-News*. July 21, 2003: A3.

Amphlett, Hilda. *Hats: A History of Fashion in Headwear*. New York, 2003.

"Art at Ellwood on Tap." *DeKalb Daily Chronicle*. July 3, 2003: 8.

Beasley, Nancy M.; Bigolin, Stephen J. "Sycamore: A Walk Through History." *Sycamore Tribune*. February 1906.

Bigolin, Stephen J. *The Barbed Wire Saga*. Gurler Heritage Association, 1983.

Bliss, Tony. "The Baron DeKalb." *Midweek*. July 12, 1978.

Boies. Henry L. *History of DeKalb County, Illinois*. Chicago, 1868.

Brauer, Gerald J. *Ellwood House An Estate of the Gilded Age*. The Ellwood House Association. DeKalb, 2001.

Brodie, Fawn M. *Thomas Jefferson, An Intimate History*. New York, 1974.

Brown, Norma. "Ellwood House." *DeKalb Daily Chronicle*. June 30, 1970.

Calvert, Catherine. "Discovering the Age of Innocence." *Victoria*. October, 1994: 123.

Conzen, Michael P. *Illinois County Landownership Map and Atlas*. Springfield, 1991.

"Creativity in Your Life." *Christian Science Sentinel*. March 19, 2001.

"DeKalb on Verge of Boom." *Chicago Sun Times*. June 13, 2003, 1W.

The DeKalb Public Library and Its Community: A Survey. 1972.

"DeKalb's Women's Club." *DeKalb Daily Chronicle*. April 22, 1990.

Duncan, Don V. *History of First Congregational Church*. Duncan, Don V., editor. DeKalb, 1985.

"Electric Park: Reflections of Yesteryear." *McCabe Crum-Halsted Real Estate Guide*.

"Ellwood Grandchild Dead at 92." *DeKalb Daily Chronicle*. January 28, 2004.

Finn-Graznak, Lisa. "Homecoming at Ellwood." *DeKalb Daily Chronicle*. August 3, 1997.

"Firemen Observe 66th Year." *DeKalb Daily Chronicle*. February 3, 1970.

"For Pete's Sake, DeKalb Airport." *DeKalb Daily Chronicle*. July 15, 2001.

Ford, Thomas. *A History of Illinois*. Chicago: University of Illinois Press, 1854.

From Oxen to Jets, A History of DeKalb County, Illinois 1835-1963. DeKalb Board of Supervisors. 1963.

"Fun Was Different in 19th Century." *DeKalb Daily Chronicle*. July 26, 1987.

Glidden Jones, Shirley. *The Thorny Cage*. 1981.

"Grand Theater Wavers." *DeKalb Daily Chronicle*. March 1, 1978.

Green, Clarence. "Baron DeKalb and His Hoosier Namesake." *Cooperative School Bulletin Butler and Auburn, Indiana*. February 1930.

Gross, Lewis M. *Past and Present of DeKalb County, Ill. Vol. l & 2*. Chicago, 1907.

Heirloom Cookbook. Prepared by N.I. Gas Company for the Illinois Sesquicentennial, 1818–1968.

Hoyter, Earl W. *Education in Transition: The History of NIU*. DeKalb, 1974.

Huddleston, Katie. "Six Acres Last Traces of Estate." *Northern Star*. October 26, 1977.

Kukla, Jon. *A Wilderness So Immense*. New York, 2003.

"Last Will and Testament of Isaac L. Ellwood, Deceased." Ellwood family.

Matthews, Jean V. *The Rise of the New Woman: The Women's Movement in America, 1875–1930*. Chicago, 2003.

North Western Lines. Chicago & North Western Historical Society. Winter 1992.

Northern Illinois Football Media Guide. DeKalb, 2003.

Northern Illinois Visitors Guide. Illinois Department of Commerce and Economic Opportunity. June 2003.

"Northern Now." *NIU Magazine*. Fall 2003.

Oliver, William. *Eight Months in Illinois*. Chicago, 1924.

Orr, Richard. "Palace a Monument to Barbed Wire." *Chicago Tribune*. November 9, 1969.

Portrait and Biographical Album of DeKalb County.

Roberts Jr., Thomas H. *The Story of the DeKalb "Ag"*. Carpentersville, 1999.

The Sandwich Fair Since 1888. Vivian C. Wright, editor. Lake Zurich, 2001.

Saxton, Martha. *Being Good-Women's Moral Values in Early America*. New York, 2003.

———. *Centennial Progress Unlimited*. DeKalb, 1856–1956.

Shepp, Daniel B.; Shepp, James W. *Shepp's World's Fair Photographed*. Chicago, 1893.

Shonle Cavan, Ruth. *Twentieth Century in the DeKalb Area*. DeKalb, 1987.

Smith, John Martin. *DeKalb County 1837–1987*. Vol. 1-3.

"Stage Coach Treks Along History's Course" *DeKalb Daily Chronicle*. July 13, 1979.

The Way We Were: A Memoir. DeKalb, 1915–1937. October l, 1996.

"The Wrights Story in Their Own Words." *Beacon News*. December 17, 2003.

ABOUT THE AUTHOR

Photo of Jo Fredell Higgins, author.

"I have no more words. Let the soul speak with the silent articulation of a face."
 –J. Rumi, 13th century

Jo Fredell Higgins is an internationally published writer and award-winning essayist and poet. She holds a master's degree in education from Northern Illinois University, DeKalb, and has taught pre-schoolers to ninety year olds during her teaching career. Her photographs have won numerous awards. One was selected to be included in the *One Day USA* book, published by the US Conference of Mayors. Jo is currently manager for the Adult Literacy Project at Waubonsee Community College in Aurora, Illinois. She was named employee of the month at Waubonsee in September 1996. She has presented at local, state, and national literacy conferences. Her volunteers have won local, state, and national awards. Jo served as chair of the GAR Commission, chair of the Aurora Township Youth Commission, is president of the board of directors for the Townes of Oakhurst, and serves on the Aurora Township Foundation board. Jo served on the city of Aurora's Riverwalk Commission advisory board in 1988. Her photo exhibits have been shown at the Aurora Public Library, as well as First Night Aurora celebrations. Jo's articles have been published in *The Instructor, Teacher, Today's Catholic Teacher, Illinois, ChildCare*, and Dublin, Ireland's *Reality* magazine, as well as 40 other publications. Her poetry has been published in *Her Echo*, a women's poetry anthology; *New Voices in American Poetry 1975;* Indiana Fine Arts Society's *"The Poet;"* the Morton Arboretum's *"White Words of Winter"* anthology; in *"A Different Drummer"*, New Jersey, 1977; and in *Poems of the World* anthology in 1998, 1999, 2000, 2003, and 2004. Jo was the official photographer for Literacy Volunteers of America-Illinois conference in 2002. Family Focus in Aurora honored Jo in 2002 for her community involvements. She volunteers with the Fox Valley Hospice, the Morton Arboretum, and the Salvation Army. Arcadia Publishing published her first book, *Naperville, Illinois*, in 2001, and her second book, *Geneva, Illinois*, in 2002. Jo was a statewide judge for Illinois Governor's Home Town Award in 2002. Jo served on the planning committee for the 2003 Midwest Literary Festival and led a panel discussion on adult literary as well as signing her two books. She is currently busy with the 2004 Midwest Literary Festival plans. Jo presented a poetry workshop at the Aurora Public Library in conjunction with the national "Make A Difference Day" in 2003. Jo was a member of the writing team at Waubonsee Community College to fashion the college "Vision" statement. Jo serves on the Parent Advisory Board for Johnson School in Aurora. She enjoys gardening, swimming, traveling, bicycling, and card games. Her daughter Suzanne and grandson Sean live in Madison, Wisconsin.